CRITTER BAKE

POLYMER CLAY

POLYMER CLAY

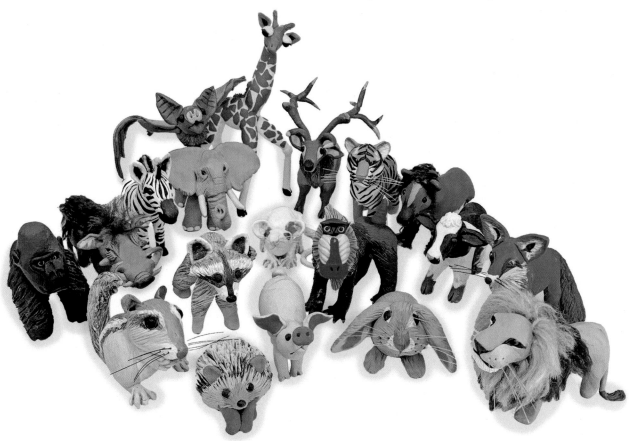

Sculpt 20 Critters with Easy-to-Follow Steps Using Polymer Clay

Joan Cabarrus

CRITTER BAKE POLYMER CLAY

Published in the United States of America in 2024 by JFCRN Limited Company Publications.

Edited by Kristin Gilger.

Front and back cover pages, illustrations, photos, and book designed by Joan Cabarrus JFCRN.

Sculpey® product photos provided by Polyform Products.

Library of Congress Control Number: 2023920766

ISBN 978-1-7332439-6-4 (Paperback)

Printed in United States of America

First printing edition 2024
1 2 3 4 5 6 7 8 9 10

www.JFCRN.com

CONTENTS

Critter Projects

 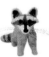

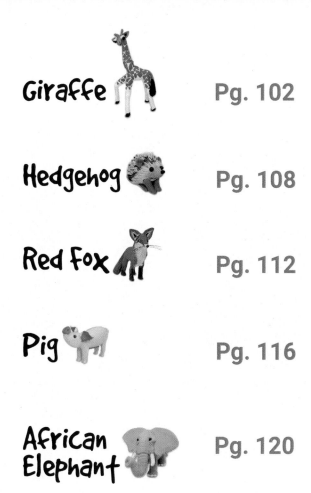

READ THIS BEFORE YOU START

The projects in this book require the use of a toaster or conventional oven. Adult supervision is advised.

Some projects incorporate yarn as part of the sculpture. Do not bake the yarn, which can be flammable. Some projects require a few clay parts to be baked before adding them to the sculpture. Strictly follow the directions on each page. The preparation pages will specify what tools are needed and which clay parts need to be baked beforehand.

Some of the clay shape labels on the preparation page are general terms used only for the purpose of this book; for example, a clay part may be described as "shoes" even when that particular animal does not have actual shoes. This is done for the sake of simplicity.

The size of the clay parts on the preparation page of each project are approximately the size you'll be making to create your sculptures. Use the preparation page as a guide.

For each project, look for the colored dot to the right side of the critter's name. This dot indicates the **project's level of difficulty**.

warthog

Easy Medium Difficult

MATERIALS

Polymer clay: Sculpey III

Polymer clay is made of plastic and some fillers. It hardens only when baked at the right temperature and length of time in an oven. For the critter projects in this book, you will need one Sculpey® III oven-bake clay (8 oz/227 g) in black, white, and hazelnut and one Sculpey III 30 Color Sampler (1.88 lbs/853 g).

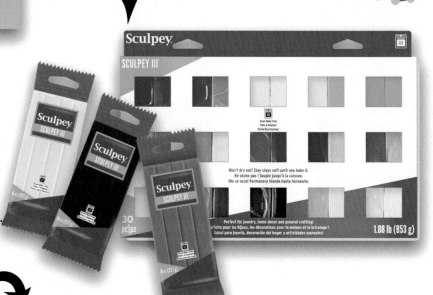

Construction Paper, Assorted Colors

You will use small pieces of construction paper or index cards to slice the clay, create indentations, create a template for clay shapes, or separate parts of the sculpture. You can use these card pieces instead of sharp tools when slicing is necessary.

Toaster oven

You will use a toaster oven to bake the sculptures. Make sure to test your toaster oven and calibrate the temperature before baking a project.

Scissors

You will use scissors to trim toothpicks, cut pieces of card, and trim yarn.

Baby oil and Soft-bristled Brush

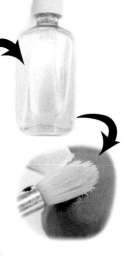

You will use baby oil and a small soft-bristled brush to eliminate fingerprints and smooth out clay surfaces.

Sculpey Oven-Bake Clay Adhesive

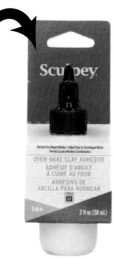

Sculpey Oven-Bake Clay Adhesive is not included in the steps to create your critter sculptures. However, it is a good way to add security between connecting parts or to fix breakages or cracks. This liquid is effective only when baked along with the sculpture.

Ball Stylus Tools

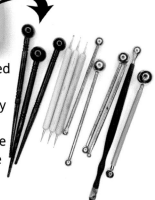

You will need a medium-sized and small-sized ball stylus tool to press or poke the clay and create dips and holes. You can also use other home tools that perform the same function.

Permanent Marker

You will use a black permanent marker to paint the whiskers for select critter sculptures. You also can use other paints as a substitute.

Fishing Line

You will use fishing line to create whiskers for select critter sculptures. Choose the thinnest line as possible.

Yarn and Clear-Gel Super Glue

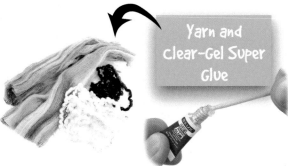

You will use black, brown, white, and beige-colored yarn to create the fur of select critters. You will add the yarn to the sculptures after the clay is baked. You will also need a fast-drying, clear-gel super glue to attach the yarn to the sculptures.

Aluminum Foil

You will use aluminum foil as a platform, carrier, stabilizer, and cover for the sculptures.

Toothpicks

You will use toothpicks to stabilize the legs, neck, and head of select critter sculptures, score the clay, create holes, and texture and poke yarn inside the fur holes.

BASIC SHAPES

Carrot Shape

Begin with a long piece of clay. Use several fingers or the palm of your hand to press one half of the clay while rolling it back and forth. Depending on the form that you need, you can make the tip sharp, round, or flat.

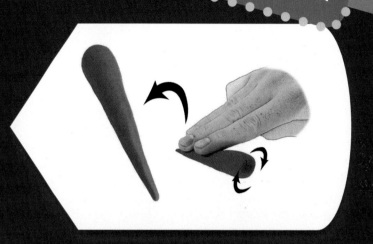

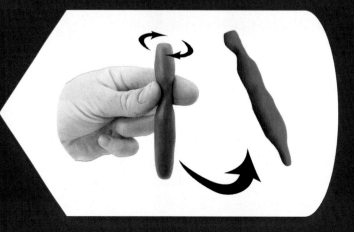

Ball Shape

Place the clay between both your palms and roll the clay in any direction to form a sphere. Use this technique to form oblong shapes as well.

Irregular Log Shape

While rolling a long piece of clay with your fingers, slightly squeeze the clay to create narrow sections. This irregular clay shape will be used to form the body and legs of select critter sculptures.

Oblong Shape

The oblong clay shape is an elongated oval and will be used to form the body, arms, neck, and head of select critters in this book. The shape and size will depend on how you roll the clay and if you flatten it.

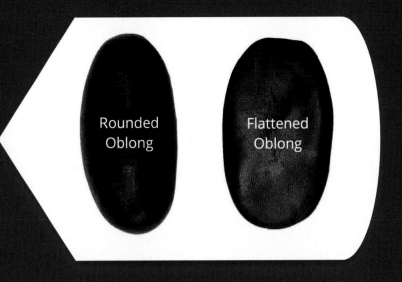

Rounded Oblong

Flattened Oblong

Diamond Shape

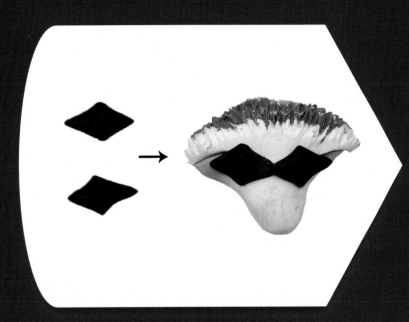

The diamond clay shape will be used to form the eye spots of the raccoon. It may be formed with rounded or pointed ends.

Thin and Thick Log shapes

The log clay shape will be used to form the arms, tails, and spots for select critters. It will also be used to create a marbling effect on the raccoon and chipmunk tails. Log shapes range from thin to thick depending on the clay part needed for the sculpture.

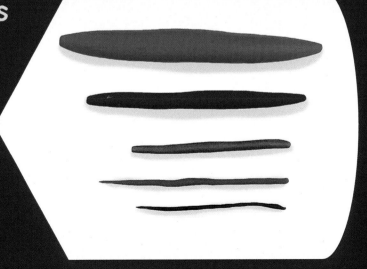

BASIC TECHNIQUES

Learn the basic techniques before you begin to create critter sculptures. You will use mainly your hands and fingers and a few tools to further form and manipulate the clay shapes.

Pinch

Pinching the clay is done by thinning a part of a clay with your fingertips. You will use this technique to combine layers of clay together, create pointed tips, and thin body parts. The amount of pressure you use will depend on how thin or thick the clay part needs to be.

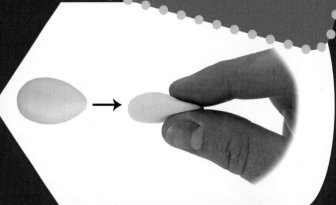

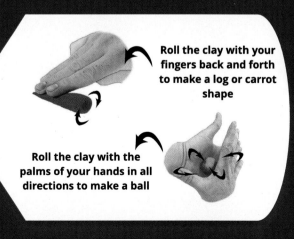

press

Fingertip Press

Pressing the clay is done by using your fingertip to create a crater-like indentation or dip and to flatten a part of the clay. The pressed part can range from shallow to deep.

Rolling

The rolling technique is used to form the carrot and ball shape. For the carrot shape, roll the clay back and forth against a hard, flat surface with your fingertips or palm. Next, put more pressure on one side of the clay while continuing to roll the clay to thin it. For the ball shape, roll the clay in a circular motion, using your fingertips when creating a small piece and your palms when creating a larger piece.

Roll the clay with your fingers back and forth to make a log or carrot shape

Roll the clay with the palms of your hands in all directions to make a ball

Poke

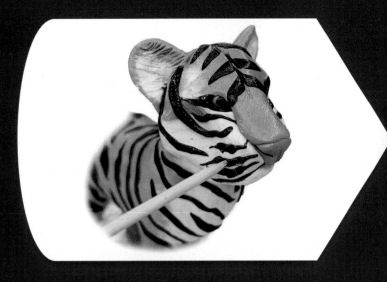

The poking technique is used to create indentations on the surface of the clay and can be done with either light or hard pressure. A ball stylus tool creates a rounded indentation while a toothpick creates a sharp indentation. The size and shape of the poke will depend on the tool.

flatten

You will use a rolling pin to evenly flatten clay against a hard, flat surface. Flattened clay will be used to form the spots of select critters. Your fingertips can also be used to flatten small pieces of clay by pressing the clay on a hard surface.

Once the flattened pieces of clay are placed and layered on top of another clay surface, they can be further flattened using the flat part of a paint brush and rolling it back and forth on the clay.

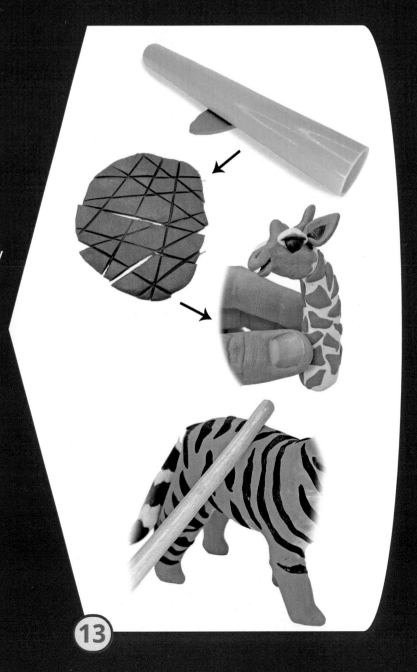

Score
(Fur and Skin Texturing)

Scoring is done by using a toothpick to create lines on the surface of the clay. You will use this technique to texture the skin or create a fur-like texture on select critters. You will apply deeper pressure on thicker clay and lighter pressure on thinner clay.

Some critters will require light scoring and other will require deep scoring.

The direction of the scores will vary depending on the critter. For example, you will create wavy scores on the elephant's face, cross-hatched scores on the elephant's body, diagonal scores on some parts of the chipmunk, and straight and long scores on the red fox.

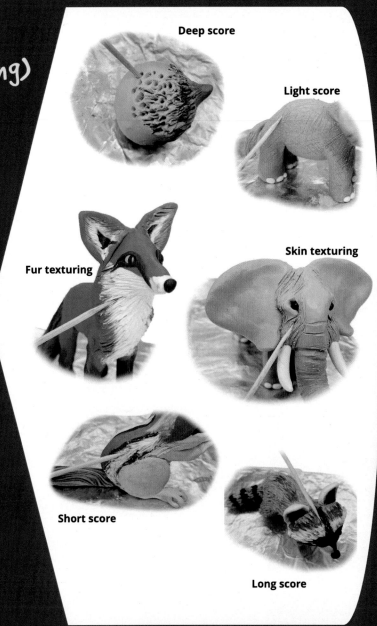

Deep score

Light score

Skin texturing

Fur texturing

Short score

Long score

Blending

Evenly blending several colors of polymer clay will help you achieve the preferred color for your critter sculptures. It is important to wash your fingertips and hands before blending different colored pieces of clay. Avoid exposing your workspace to lint, dust, or animal fur.

Brown + White = Tan

Marbling

Marbling, which is done by twisting differently colored pieces of clay, is used to create color patterns for select critters. You will use this technique to create the tail for the chipmunk and raccoon.

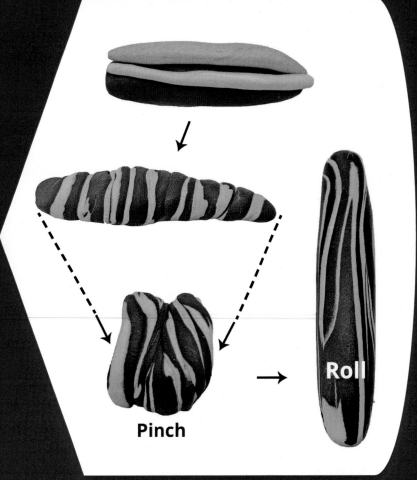

Pinch

Roll

Smearing

The smearing technique is used to create gradients of color on the surfaces of the sculptures. Smearing transitions the clay color from dark to light and vice versa. You will use your fingertips to slowly smear just the very edge or tip of one clay to another repeatedly. The directions will specify which clay parts to smear and in which direction.

Heavy smearing

Light smearing on thin border

Smearing only select parts

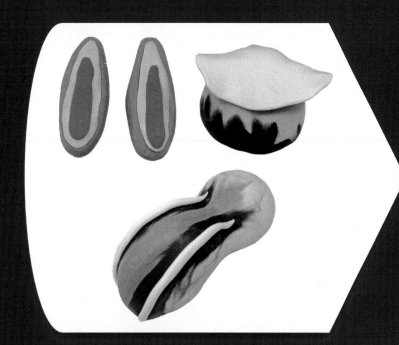

Color Layering

Color layering is done by adding one or more different colored pieces of clay on top of a shaped clay. This includes adding colored spots to a sculpture.

Soft clay on Baked clay

For some sculptures, you will apply soft clay to a baked clay piece; for example, adding the unbaked base clay to the tip of the baked tusk clay for the elephant.

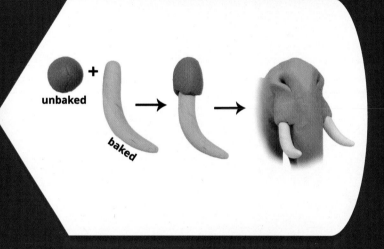

Baked clay on Soft clay

You will bake some clay parts before adding them to the sculpture. This will preserve the color and shape of the baked clay parts while you form the rest of the sculpture.

Always follow the directions on the package insert for baking your sculptures. You will bake the small pieces of clay at 250°F for 2 minutes. Make sure that your piece is securely situated inside the oven and does not touch any of the oven surfaces.

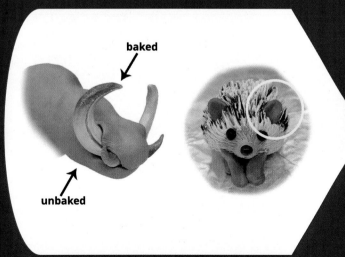

Toothpick Skewers

You will use toothpicks to connect larger pieces of clay. Trim the toothpicks by cutting them with scissors. Make sure that the tip that will connect to the body is long enough to create stability but not long enough to be exposed. The other tip of the toothpick should be exposed; it will be covered with clay for the paws. Use longer toothpicks to connect the heads of critters with longer necks.

Some critters' legs will have skewers that are hidden. Other critters will have overlapping skewers to create very long leg formations or a bent skewer to create a bent leg, like for the giraffe.

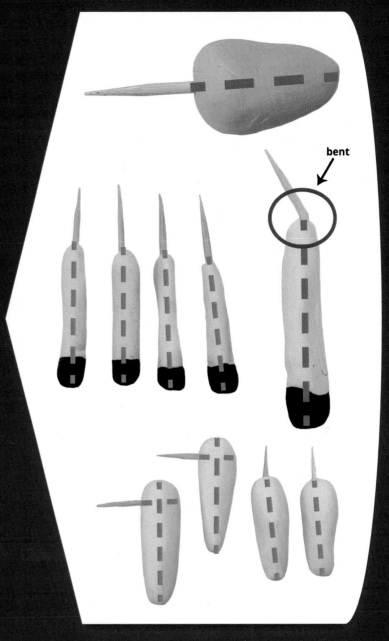

bent

Connecting Parts

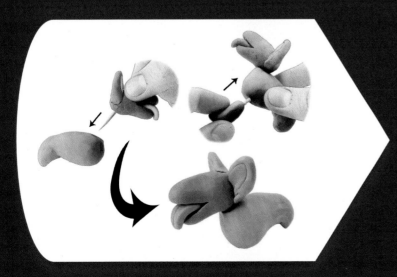

You will use toothpicks to help connect select parts of your critter sculptures, such as the head and neck to the body, legs to the body, and tail to the body. Pay special attention to the instructions regarding the location and maneuvering of connecting parts, as these steps vary depending on the shape and length of the critter's body parts.

Adding Spots

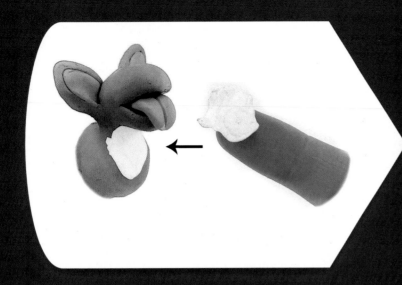

To create spots on a critter's fur or skin, you will use very thin layers of clay. Begin by creating a small ball shape, then pinch it with your fingertips or flatten it with a rolling pin. Some spots are irregularly shaped and can be created by stretching the sides of the thin clay with your fingers.

Adding Ears

The shape of the ears depends on the critter. Some critter have erect ears, and some have droopy ears. The construction of ears is mostly directional.

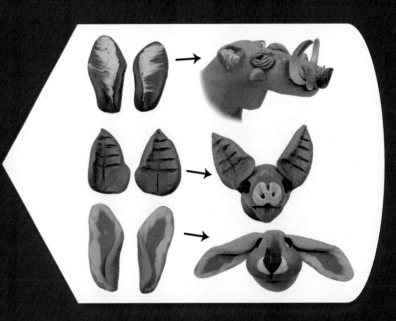

Adding Eyes

You will create eyes with small balls of clay. Some critters' eyes will have eye spots or extra clay before adding the baked eyeballs. You will bake the small pieces of clay at 250°F for 2 minutes.

Adding Clay Tails

A tail is formed by creating a long piece of log-shaped clay. Take note that narrower pieces of clay are at greater risk of breaking, so handle the baked, cured sculpture with care. The shape and stance of the tail depends on the critter. Some critter tails require texturing, and some do not. You will connect the tails by smearing the connecting clay towards the buttocks of the critter sculpture. Some critters will have fur tails made of yarn.

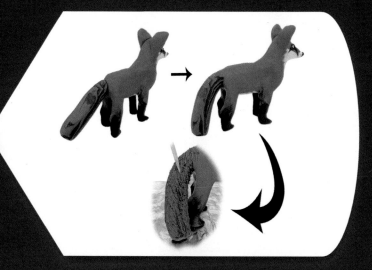

Adding Yarn fur

Yarn can be used to imitate some critters' fur. **NOTE: Do not bake the yarn with the sculpture; it could be flammable.** Tie knots in the middle or tip of the yarn pieces to prevent them from falling apart. Before baking the clay sculpture pieces, poke holes that are large enough to fit the knots. After baking, you will use super glue to secure the knotted yarn in the holes. You can then trim the yarn with scissors after the glue dries. Strictly follow the instructions for each critter with yarn fur.

knot

Adding Whiskers

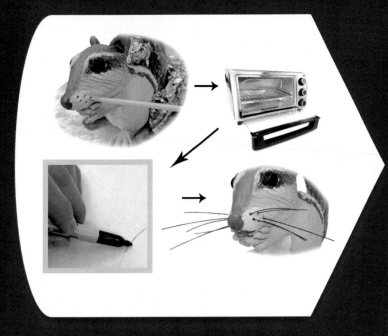

You will use fishing line to create the whiskers of select critters. You will poke small holes with a toothpick to create the whisker pores on the critter's face. When placing the whiskers into the pores, dip the small tip of the whisker in clear-gel super glue, then place it immediately inside the pore with the whisker pointing down or sideways. Trim all the whiskers after the glue dries.

Shaping the Legs

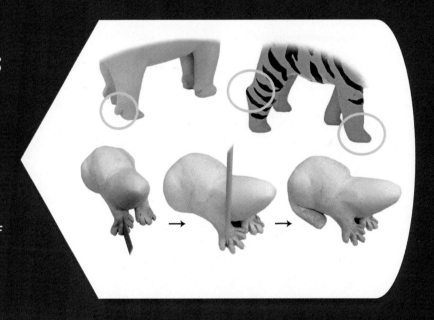

You will shape the legs of select critters by pinching some parts and slicing the clay to create toes. You will use the pinching technique on the elbows and hocks of some critters' legs.

Slicing with a card form

You will use pieces of card to slice some parts of the sculptures, create clay spots, form curves, remove excess clay, and create indentations.

20

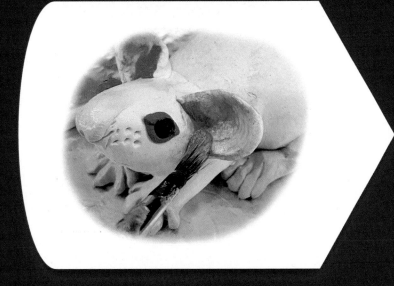

Blending Colored Clay with Oil

This technique will only be used for the mouse's ears. It will require the use of a brush and small amount of baby oil to dissolve the thin color-layered clay on top of the base clay.

Smoothing and Removing Fingerprints

Your fingers will leave prints on the clay after you handle and shape the sculpture. You can use a soft-bristled brush and a drop of oil to help smooth and remove fingerprints and any excess clay after texturing. Do this right before baking, when the sculpture is already on the baking foil sheet.

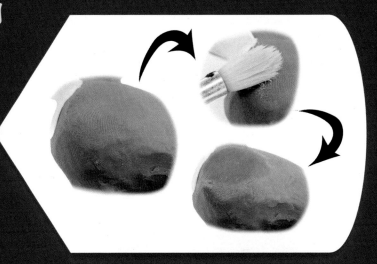

Preparing to Bake

For critters that are standing, prop the sculpture upright with extra aluminum foil to create stability before baking. Polymer clay softens in the oven when it is hot, so there is a risk of some thin parts breaking. You can also prop parts of the sculpture with small pieces of aluminum foil before baking; for example, the individual horns of the elk.

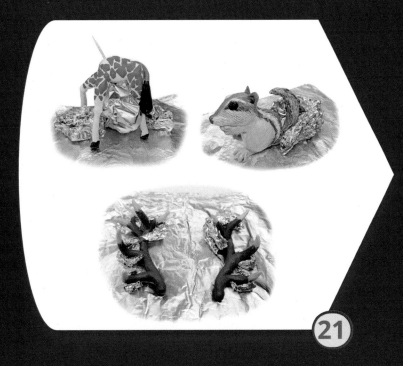

Baking the Sculpture in a Toaster Oven

Make sure to test your oven and calibrate the temperature before baking a project. Always follow instructions on the package insert for baking your sculptures. You will bake whole sculptures at 250°F for 20 minutes. Very small and very thin pieces will be baked for 1-2 minutes at 250°F. Make sure that your aluminum foil platform is flat. Cover the sculptures with aluminum foil to prevent scorching.

Fixing Cracks or Breakage

Cracks in a sculpture can occur during baking, and breakages can result from mishandling. In such cases, use Sculpey Oven-Bake Clay Adhesive to reattach the broken pieces and then rebake the piece according to the package insert (250°F for 30 minutes).

20

critter

Projects

Barbary Lion

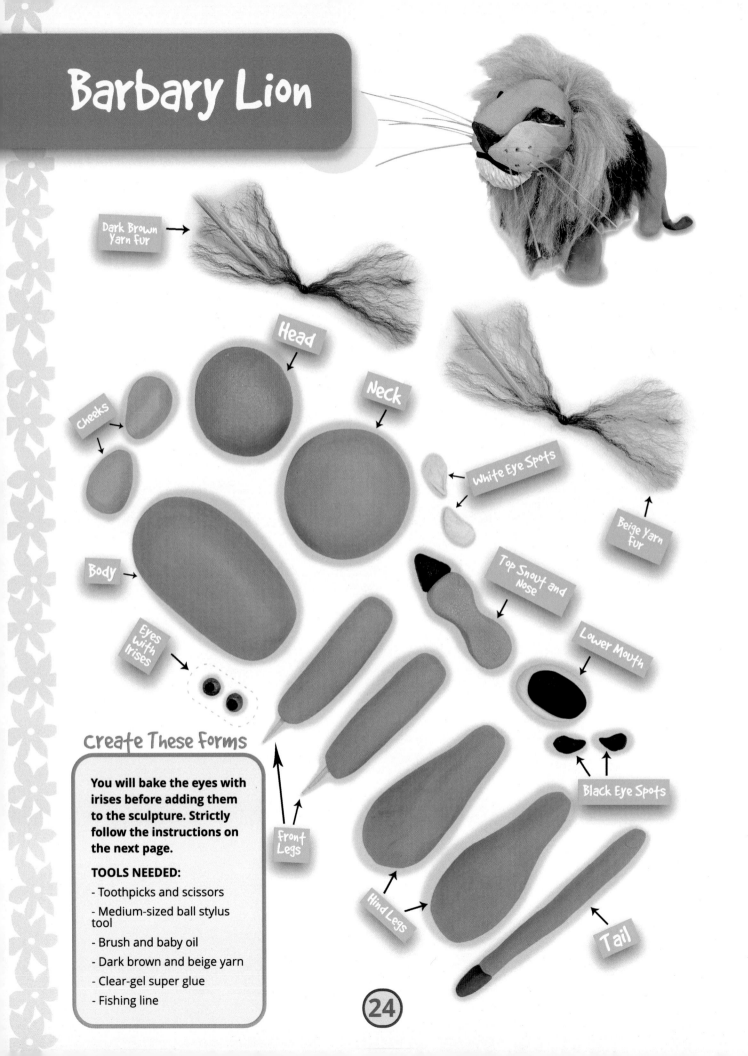

Dark Brown Yarn Fur

Head

Neck

Cheeks

White Eye Spots

Beige Yarn Fur

Body

Top Snout and Nose

Lower Mouth

Eyes with Irises

Black Eye Spots

Front Legs

create These forms

You will bake the eyes with irises before adding them to the sculpture. Strictly follow the instructions on the next page.

TOOLS NEEDED:
- Toothpicks and scissors
- Medium-sized ball stylus tool
- Brush and baby oil
- Dark brown and beige yarn
- Clear-gel super glue
- Fishing line

Hind Legs

Tail

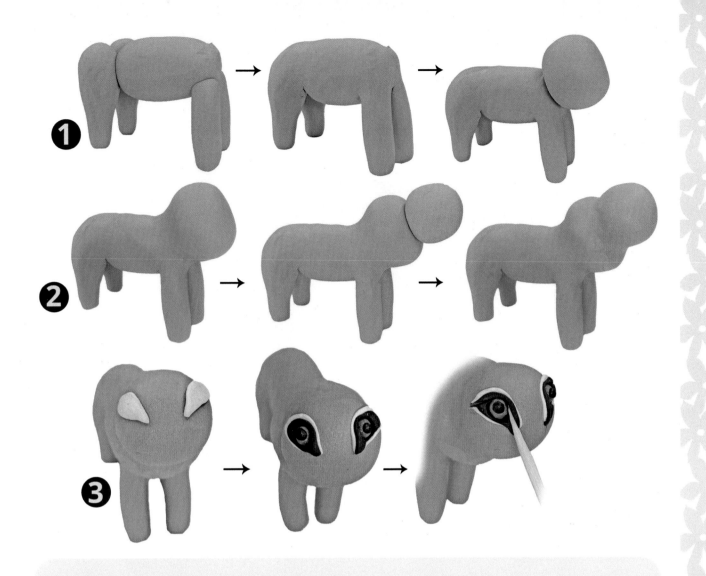

❶ Attach the front and hind legs to the body then blend the connections.

Attach the neck to the front part of the chest.

❷ Blend the neck connection towards the body.

Attach the head to the front of the neck then lightly smear the connection from the head towards the neck.

❸ Place the white eye spots pointing inward and downward on the face.

Place the black eye spots on top of the white eye spots.

Lightly depress a baked eye with iris on each of the black eye spots.

Score the inner and outer corner of the eye spots with a toothpick to create a cat-eye look.

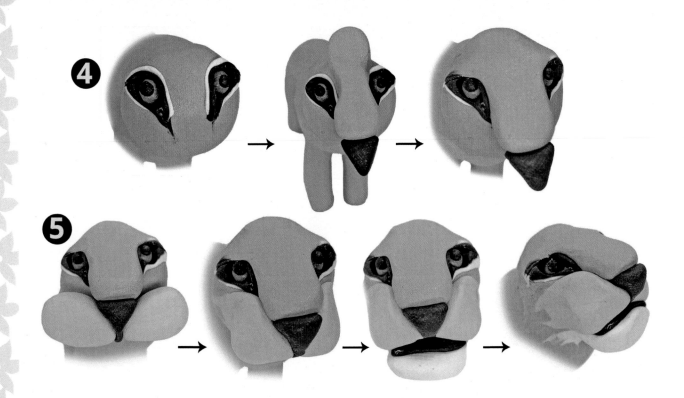

4 Place the top snout and nose clay vertically and pointing downwards on the front of the face then smear the connection only at the top, covering the top edge of the eye spots.

5 Attach the cheeks on each side of the lower face then lightly smear the connection only on the sides away from the nose.

Attach the lower mouth below the snout then smear the connection only on the neck area.

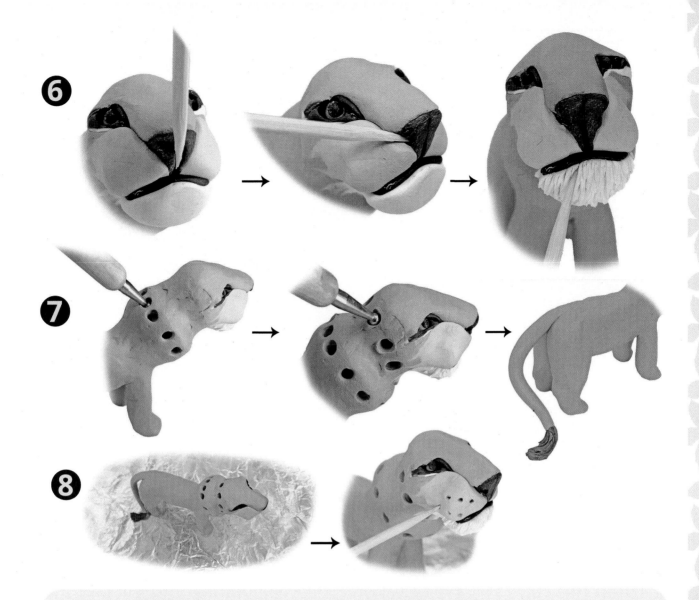

6 Use a toothpick to score a vertical line in the middle of the nose.

Score a line on each side of the nose in between the nose and the cheeks. This will create the nostrils.

Texture the white part of the lower mouth by scoring vertical lines with a toothpick.

7 Poke 12 holes around the neck and 8 holes around the head with a medium-sized ball stylus tool.

Attach the tail then blend the connection. Texture the end tip of the tail by scoring it with a toothpick.

8 Place the sculpture on a foil platform.

Poke 6 small holes on each cheek with a toothpick.

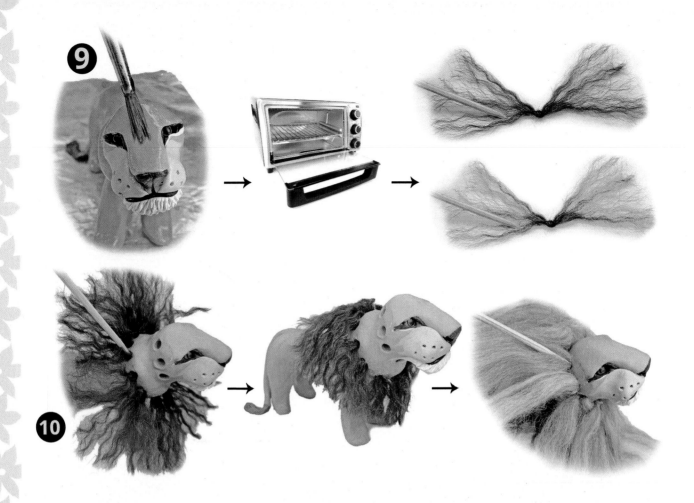

9 Smooth the surface of the sculpture with a brush and small amount of baby oil.

Bake the sculpture at 250°F for 20 minutes. Wait until the sculpture cools off before handling to prevent breakage.

Prepare the yarn fur. Create 12 pieces of dark brown yarn fur and 8 pieces of beige yarn fur. Tie knots in the middle of each yarn fur. Make sure the knots are small enough to fit in the pores on the sculpture. Use a toothpick to separate the threads of the yarn piece.

10 Apply a small amount of clear-gel super glue in one hole of the neck then insert one knotted dark brown yarn fur with a toothpick. Repeat this process for all the holes on the neck (12 total).

Flatten the yarn fur with a toothpick.

Apply a small amount of clear-gel super glue in one hole of the head then insert one knotted beige yarn fur with a toothpick. Repeat this process for all the holes on the neck (8 total).

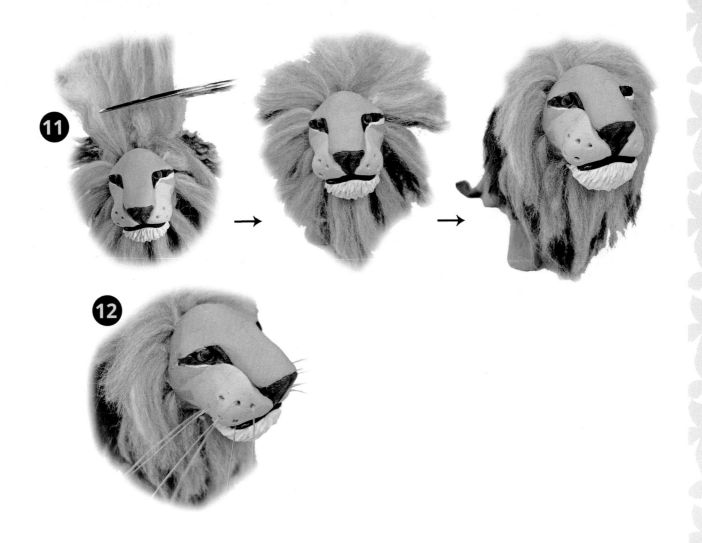

11 Trim the bangs of the lion with scissors then comb all the yarn fur down with a toothpick.

12 Dip the small tip of the fishing line in clear-gel super glue then place it immediately inside the whisker pore, with the whiskers pointing down.

Trim all the whiskers after the glue dries.

Albino White Mouse

Create These forms

You will bake the red eyeballs before adding them to the sculpture. Strictly follow the instructions on the next page.

TOOLS NEEDED:
- Toothpicks and scissors
- Brush and baby oil
- Clear-gel super glue
- Fishing line

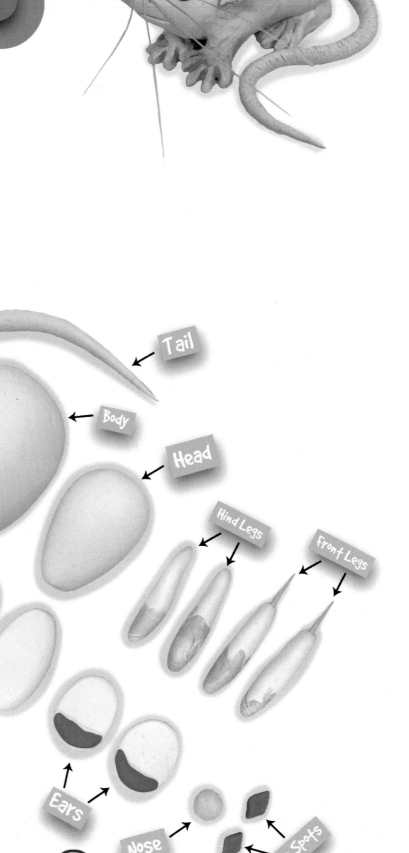

Tail

Body

Head

Hind Legs

Front Legs

Eyeballs

Thighs

Ears

Nose

Eye Spots

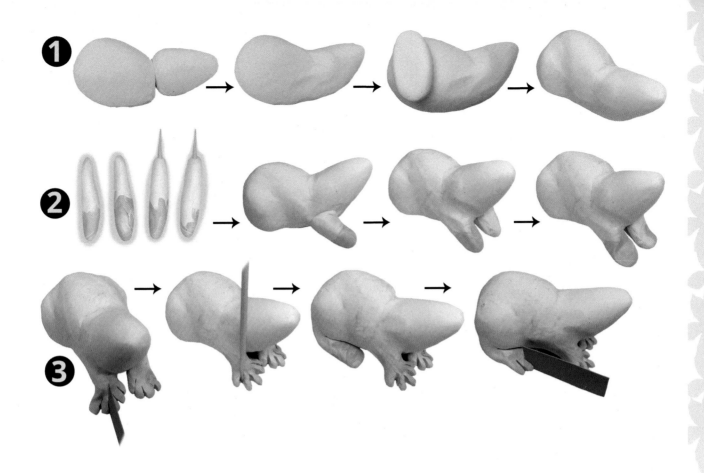

❶ Attach the head to the body then blend the connection.

Attach a thigh on one side of the bottom of the body then blend the connection. Repeat this process for the other thigh.

❷ Prepare the front and hind legs. Attach the front legs to each upper side of the body then blend the connections. Pinch the tips of the front legs to create paws.

❸ Use a card piece tool to slice the individual fingers on each paw with four evenly spaced cuts. Individually separate the fingers with a toothpick then lightly press the middle part to create dips. Form each finger to have a rounded tip.

Attach the hind legs to the bottom sides of the body.

Repeat the process of shaping the fingers to make the toes.

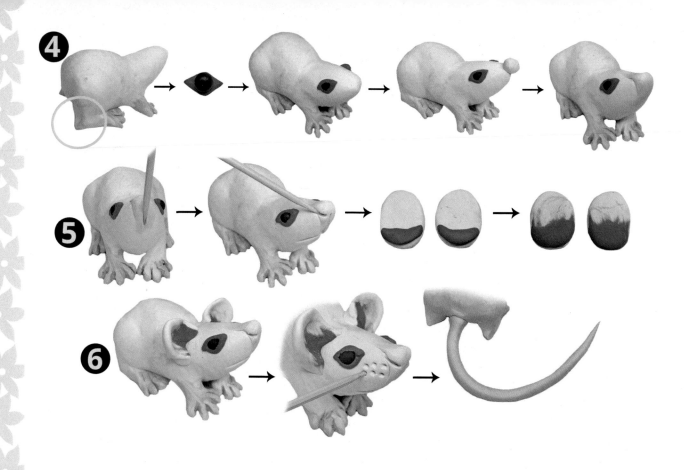

4 Form the back of the hind legs to be slightly pointed.

Prepare the eye formation. Place the baked eyeball on top of the unbaked diamond-shaped eye spots. Next, place this eye formation on each side of the head.

Add the nose then smear the top portion towards the snout and the bottom portion down towards the mouth.

5 Using a toothpick, score the front part of the nose with one vertical line in the middle and a diagonal line on each side of the nose for the nostrils. Score a horizontal line for the mouth.

Prepare the ears. Lightly smear the pink clay on the white clay.

6 Attach the ears to the upper sides of the head then blend the connections.

Poke six holes on each side of the mouse's cheeks with a toothpick for the whisker pores.

Attach the tail.

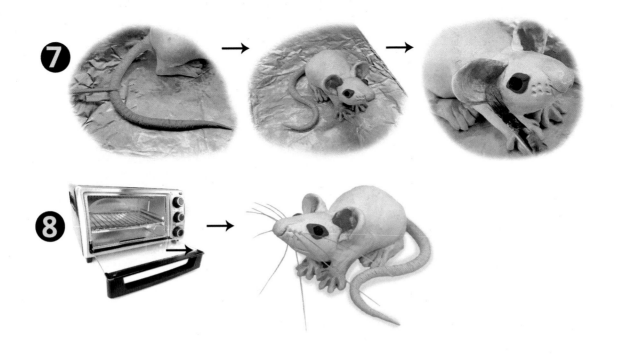

7 Place the mouse sculpture on a foil platform.

Texture the tail with a toothpick with light scoring and horizontal lines. Maneuver the tail to create the desired look.

Blend the color of the inner part of the mouse's ears with a brush and small amount of baby oil.

8 Bake the sculpture at 250°F for 20 minutes. Wait until the sculpture cools off before handling to prevent breakage.

Dip the small tip of the fishing line in clear-gel super glue then place it immediately inside the whisker pore. Repeat for all the whiskers (12 total).

Trim all the whiskers after the glue dries.

Belgian Draft Horse

create These forms

You will bake the eyes before adding them to the sculpture. The front and hind legs have hidden toothpick skewers in them. Strictly follow the instructions on the next page.

TOOLS NEEDED:
- Toothpicks and scissors
- Medium-sized ball stylus tool
- Brush and baby oil
- Dark brown yarn
- Clear-gel super glue
- Piece of card

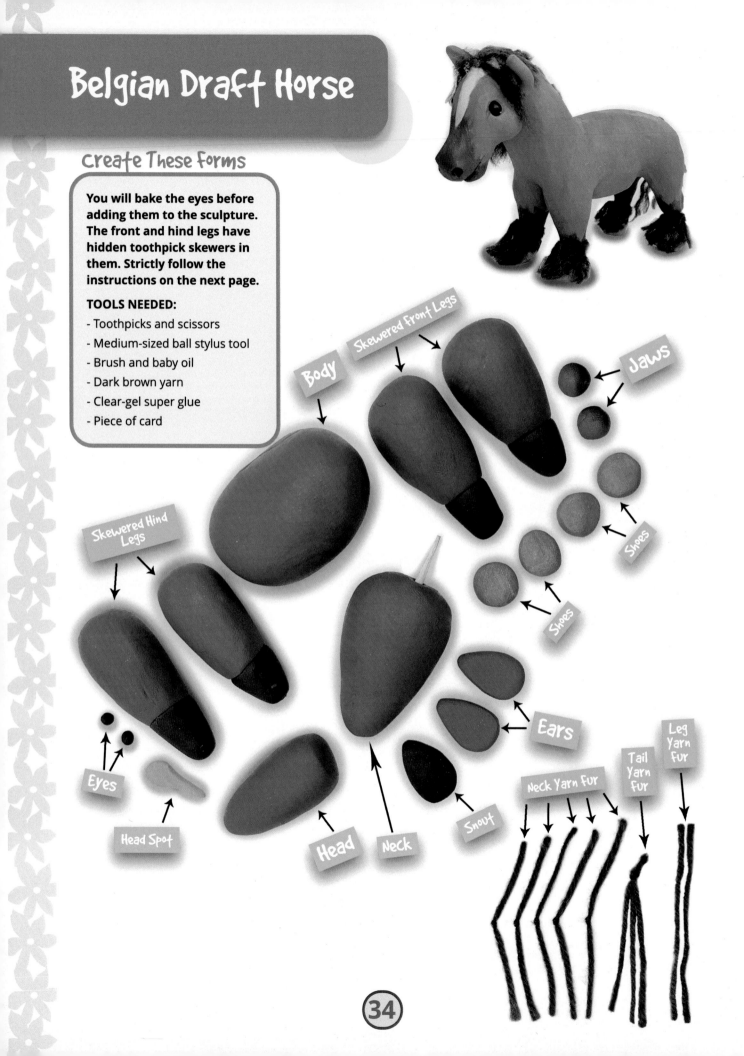

Body

Skewered Front Legs

Jaws

Skewered Hind Legs

Shoes

Shoes

Eyes

Head Spot

Head

Neck

Snout

Ears

Neck Yarn fur

Tail Yarn fur

Leg Yarn fur

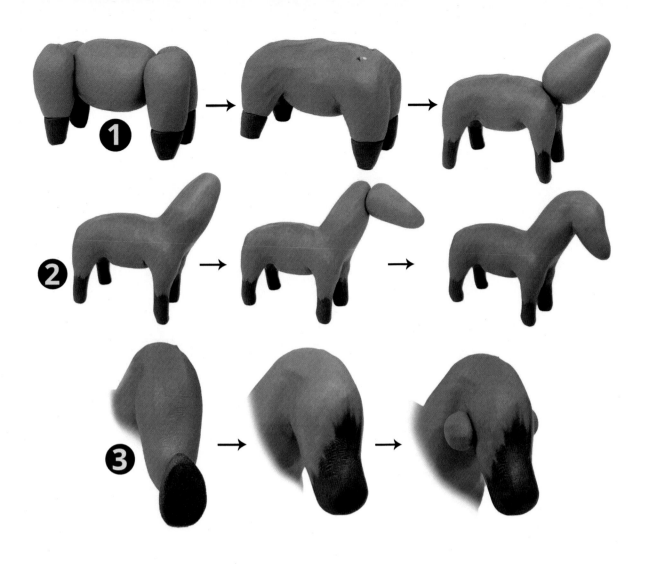

❶ Attach the front and hind legs to the body then blend the connections. Elongate all four legs and form them into thinner shapes. Lightly smear the dark brown clay upwards.

Attach the neck diagonally at the top of the chest area.

❷ Blend the connection between the neck and the body.

Attach the head to the front top tip of the neck then blend the connection. Point the head downward.

❸ Place the snout on the front of the head and wrap it around the sides. Lightly smear the snout towards the head.

Add the jaws to each side of the head.

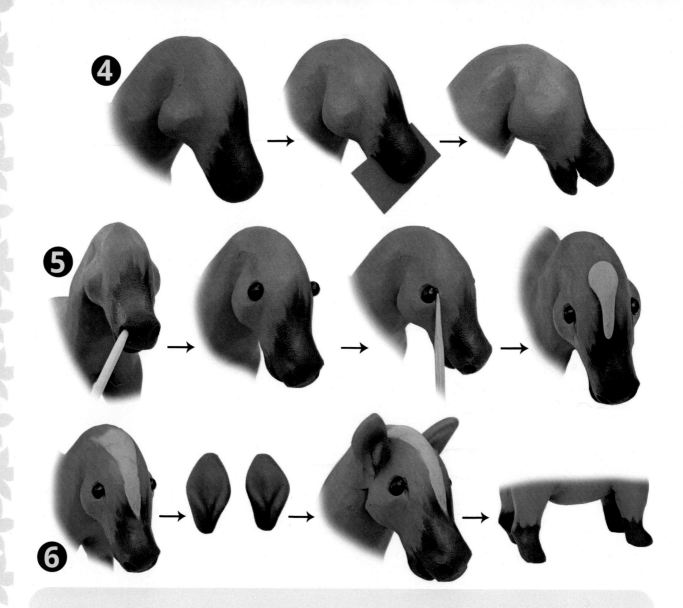

4 Blend the connection between the jaws and the head.

Create a mouth by slicing the clay with a piece of card horizontally. Open the mouth then lightly press on the lower mouth to shorten it.

5 Poke a hole in each front side of the snout with a toothpick to create the nostrils.

Add the baked eyes to each side of the head. Score the inner eyes with a toothpick to create the eye corners.

Place the head spot on top of the forehead.

6 Lightly smear the edges of the head spot.

Curl inward the bottom sides of each ear. Attach the ears to each side of the the head facing forward then blend the connections.

Form all the feet pointed and pinch the back part of the foot to form the hocks.

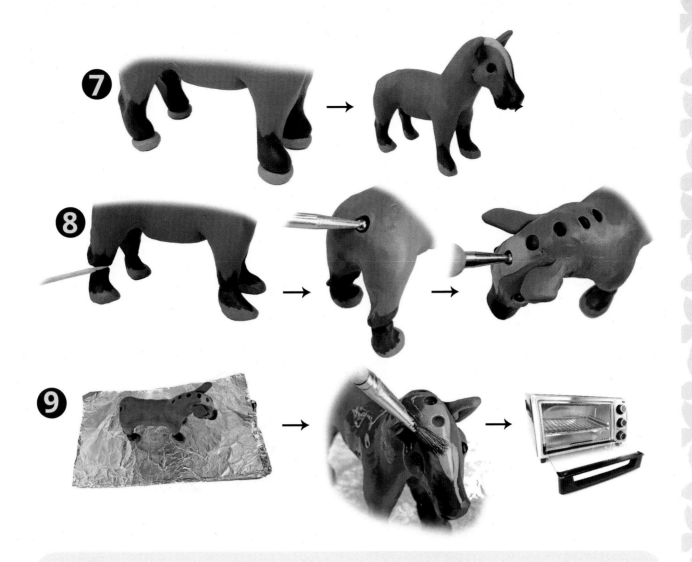

7 Attach the four shoes to the bottom of the feet then smear the connections.

8 Create an indentation around each middle leg with a toothpick. This will create a space for the leg yarn furs.

Poke one hole on the upper part of the buttocks with a medium-sized ball stylus tool to create a tail fur pore.

Poke 5 holes from the top of the head down the back of the neck with the ball stylus tool to create the neck fur pores.

9 Place the sculpture on a foil platform.

Smooth the surface of the clay with a brush and small amount of baby oil.

Bake the sculpture at 250°F for 20 minutes. Wait until the sculpture cools off before handling to prevent breakage.

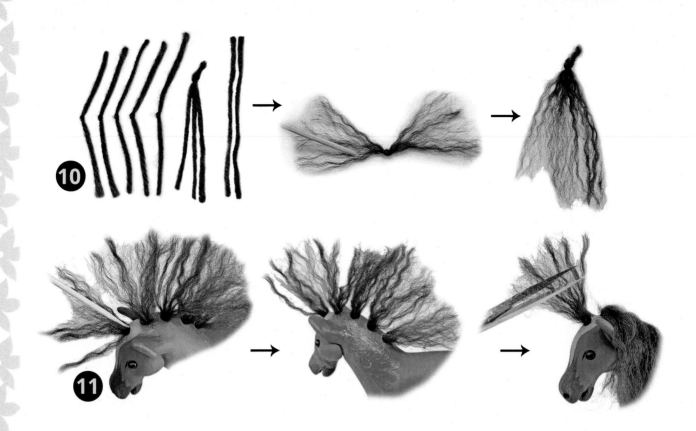

10 Prepare all the yarn furs. Make sure to create a knot in the middle part of the five neck yarn furs and a knot at the end tip of the tail fur. Leave the leg yarn furs unknotted. **Note: The knots will keep the fur intact. These knots will also be inserted in the pores.**

Comb the five neck yarn furs and the tail yarn fur with a toothpick.

11 Apply a small amount of clear-gel super glue in one neck pore then insert one knotted neck yarn fur in the hole with a toothpick. Repeat this process for all the neck holes.

Flatten the neck yarn fur with a toothpick. Apply dabs of clear-gel super glue underneath the neck yarn fur and press the neck yarn fur to adhere to the neck. Take the yarn fur from the top of the head then trim it with scissors.

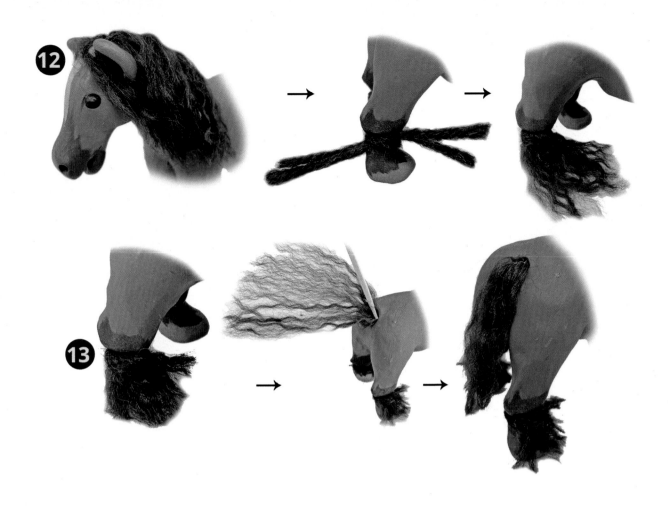

12 Comb and flatten all the neck yarn fur on one side of the neck.

Take one set of leg yarn fur and place it on the indented part of the leg. Wrap it around one leg then secure it by making a knot. Comb the leg yarn fur with a toothpick. Repeat this process for all the leg yarn fur.

13 Trim the all the leg yarn fur with scissors.

Apply a small amount of clear-gel super glue in the tail pore then insert the knotted tail yarn fur in the pore with a toothpick.

Comb down and flatten the tail yarn fur. Secure it to the surface of the sculpture with a dab of clear-gel super glue.

Gorilla

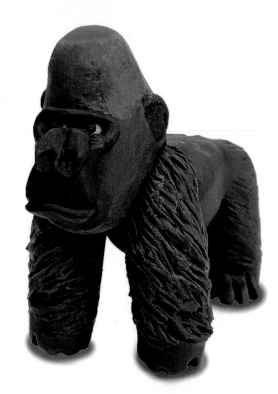

create These forms

You will bake the eyes with irises before adding them to the sculpture. Strictly follow the instructions on the next page.

TOOLS NEEDED:

- Toothpicks and scissors
- Medium-sized ball stylus tool
- Brush and baby oil
- Piece of card

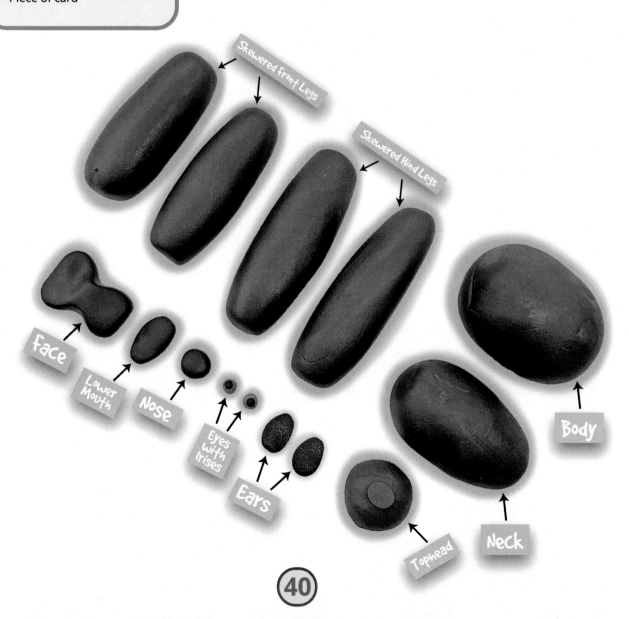

Skewered Front Legs

Skewered Hind Legs

Face

Lower Mouth

Nose

Eyes With Irises

Ears

Body

Neck

Tophead

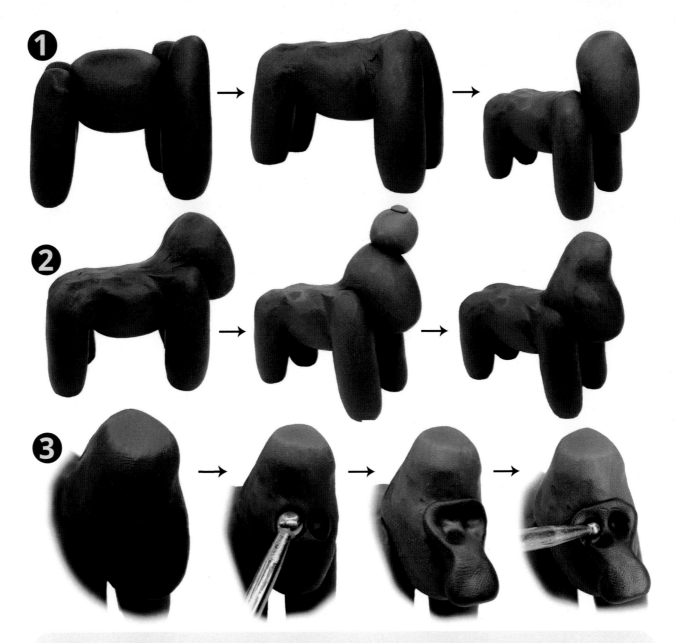

1 Attach the front and hind legs to the body. The front legs are longer than the hind legs. Make sure that the front legs are sticking up a little higher than the body. Blend the connections.

Attach the head to the front of the body.

2 Blend the connection between the head and the body only at the back.

Attach the tophead to the top of the head then blend the connection.

3 Smear the orange part of the tophead clay to create a color gradient.

Poke two holes with a ball stylus tool to create eye sockets.

Place the face clay vertically at the front of the head then poke two holes again in the same eye sockets placement.

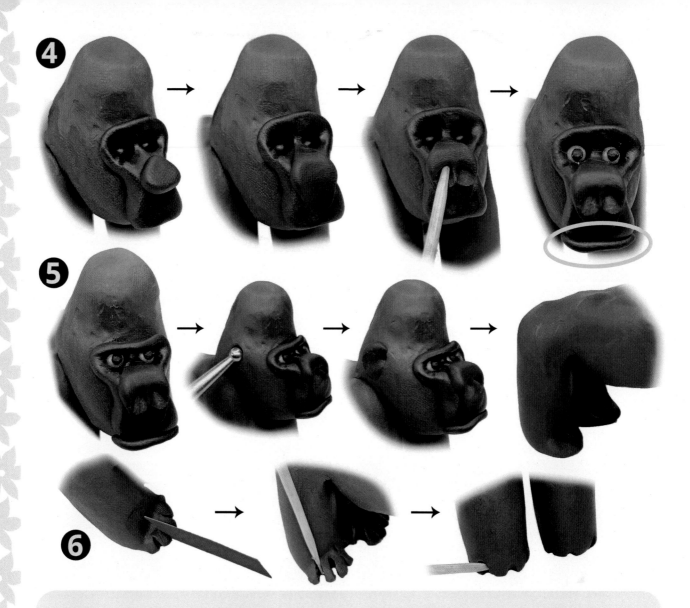

4 Add the nose to the front of the face then blend the connection only at the top and bottom. Poke two holes upward on the nose with a toothpick to create the nostrils.

Place the baked eyeballs inside the eye sockets. **Note: Maneuver the eyeballs to where you want the gorilla to look.**

Attach and lightly flatten the lower mouth under the face.

5 Maneuver the eyebrows down to lightly cover the eyeballs.

Poke one hole with a ball stylus tool on each side of the head for the ear placements. Place the ears in the holes.

Lightly pinch the tips of the hind legs to create the feet.

6 Use a card piece tool to slice individual toes in each foot with four evenly spaced cuts. Separate the big toes far apart from the rest with a toothpick.

Create four evenly separated indentations under each front leg to create the knuckles.

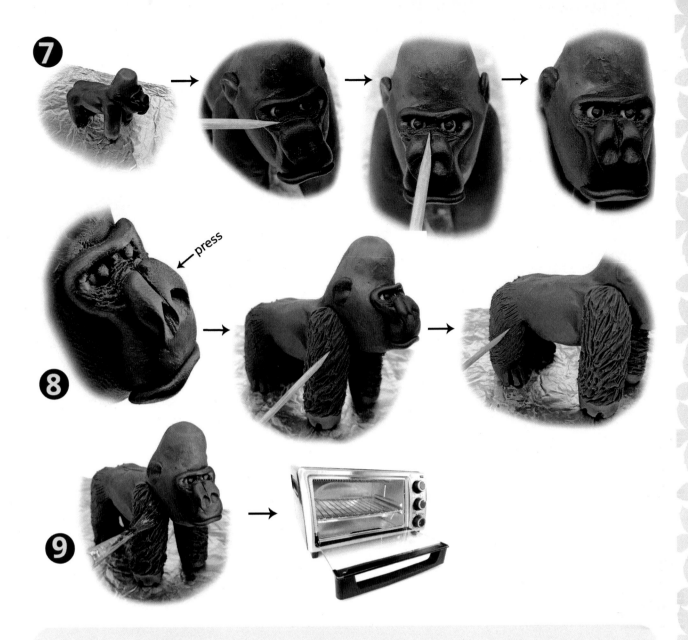

⑦ Place the gorilla sculpture on a foil platform.

Score and texture the top of the snout with a toothpick horizontally. Create an indentation in a vertical line with a toothpick in the middle of the nose.

⑧ Using your finger, lightly press the middle part of the nose to flatten it.

Texture the front legs by scoring deep, diagonal lines with a toothpick and then score light lines on the hind legs.

⑨ Lightly smooth the surface of the gorilla sculpture with a brush and small amount of baby oil.

Bake the sculpture at 250°F for 20 minutes. Wait until the sculpture cools off before handling to prevent breakage.

Zebra

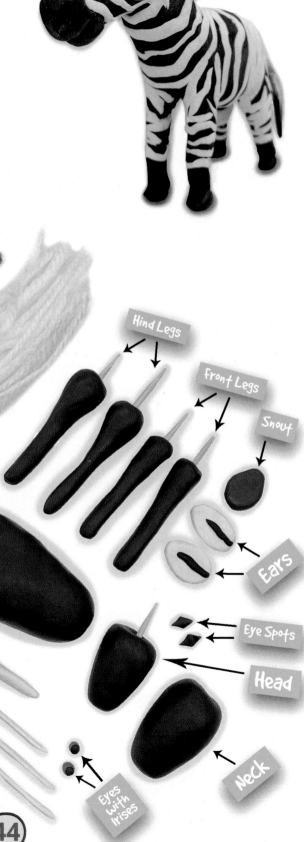

create These forms

You will bake the eyes with irises before adding them to the sculpture. Strictly follow the instructions on the next page.

TOOLS NEEDED:
- Toothpicks and scissors
- Brush and baby oil
- White and black yarn
- Clear-gel super glue
- Piece of card

Black Yarn fur →

White Yarn fur →

Hind Legs

Front Legs

Snout

Ears

Eye Spots

Body →

Tail →

Head

White Spots →

Neck

Eyes with Irises

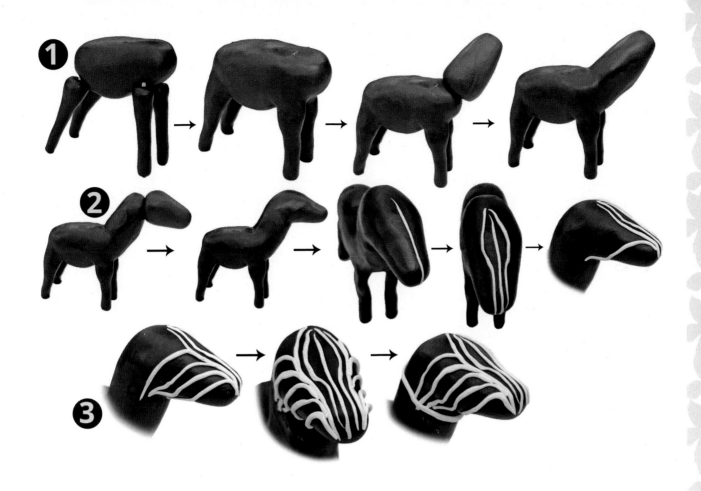

1 Attach the front and hind legs to the body then blend the connections.

Attach the neck to the front of the body then blend the connection.

2 Attach the head to the top front of the neck then blend the connection.

Place one spot vertically along the middle of the face. Add two more spots on each side of the first spot. Add another spot starting from the front snout down each cheek to the neck.

3 Add more spots on both sides of the cheeks following the pattern and distributing them evenly. Add one spot around the neck.

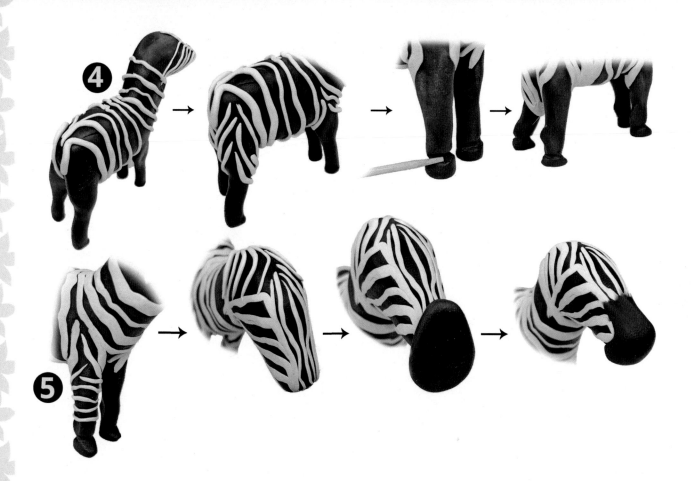

4 Add more spots to the body starting from the neck and moving down the body. Distribute the spots evenly. Add more spots diagonally on both thighs. Flatten all the spots by rolling the flat part of a paint brush over the clay. It serves as a mini rolling pin.

Create indentations at the bottom of each leg with a toothpick to create a shoe-like formation. Pinch the back part of the hind legs to create the hocks.

5 Add thinner spots to both of the front legs in a vertical pattern then flatten them on the body.

Add more spots on top of the head in a diagonal pattern then flatten them.

Attach the dark brown snout to the front of the snout then wrap it around. Smear only the top middle part of the snout.

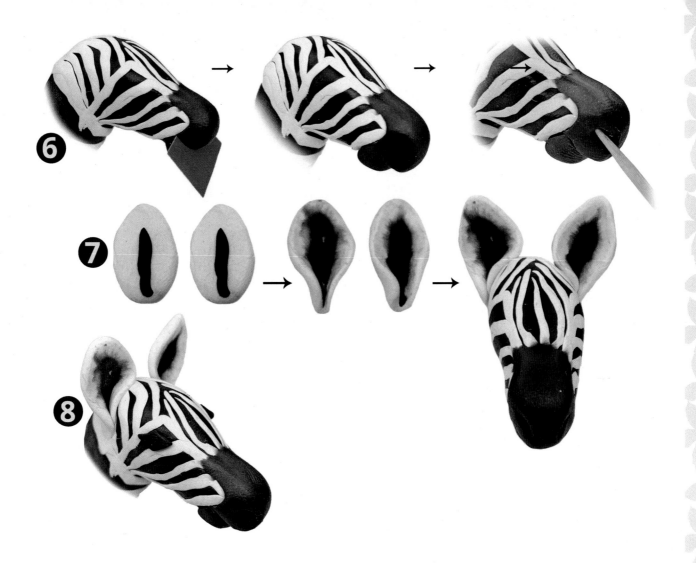

6 Slice the snout with a card piece tool. Separate the top and bottom then press the bottom snout in to create an overbite look. Lightly pinch the front part of the snout with your thumb and index finger.

Poke a hole on each side of the snout to create the nostrils.

7 Prepare the ears. Lightly smear the black clay outward to create a color gradient on the inner part of the ears. Curl the bottom part of the ears inward then attach them on the upper sides of the head.

8 Decide where you want to place the eyes on the face then add the diamond eye spots.

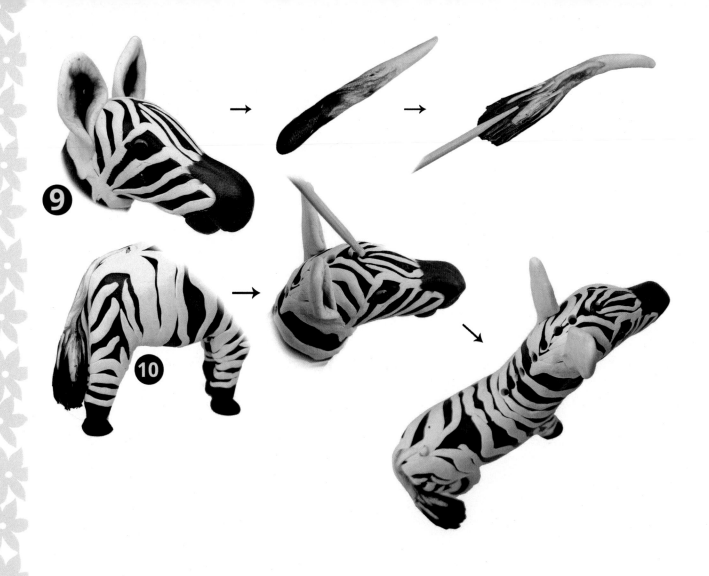

9 Add the baked eyes to the front of the eye spots. Press in both baked eyes to adhere.

Prepare the tail. Score the dark part of the tail with a toothpick to create a hairlike texture.

10 Attach the tail to the buttocks area of the zebra then blend the connection.

Using a toothpick, poke 11 holes from the top of the head along the middle spine. Make sure the holes are big enough for the yarn fur to be added in.

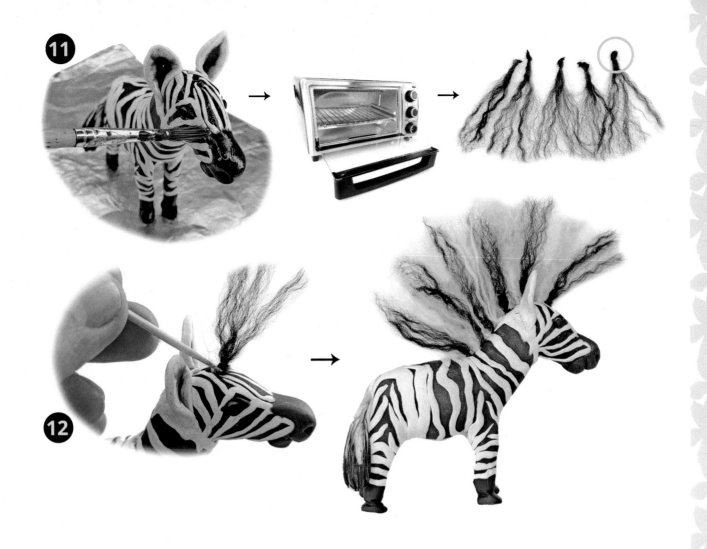

11 Place the sculpture on a foil platform.

Smooth the surface of the sculpture with a brush and small amount of baby oil.

Bake the sculpture at 250°F for 20 minutes. Wait until the sculpture cools off before handling to prevent breakage.

Prepare the yarn fur. Create 6 black yarn pieces and 5 white yarn pieces. Tie knots at the ends of the yarn pieces. Make sure the knots are small enough to fit in the pores.

12 Apply a small amount of clear-gel super glue in one hole using a toothpick. Insert the knot of one black yarn fur inside the first hole. Repeat for the remaining yarn furs. **Note: Alternate inserting black and white yarn fur in the holes.**

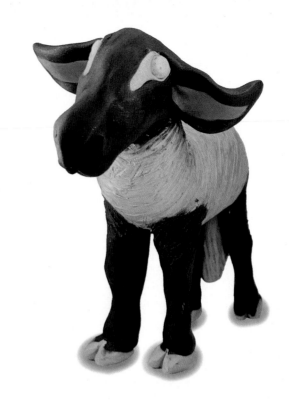

create These forms

Strictly follow the instructions on the next page.

TOOLS NEEDED:

- Medium-sized ball stylus tool

- Toothpicks

- Brush and baby oil

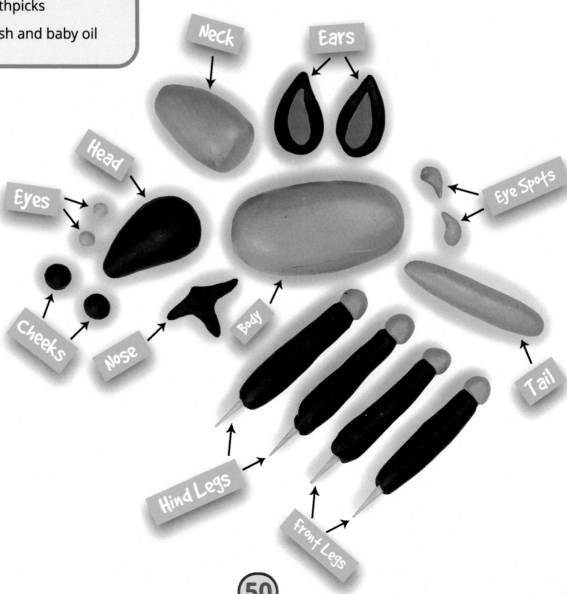

Neck

Ears

Head

Eyes

Eye Spots

Cheeks

Nose

Body

Tail

Hind Legs

Front Legs

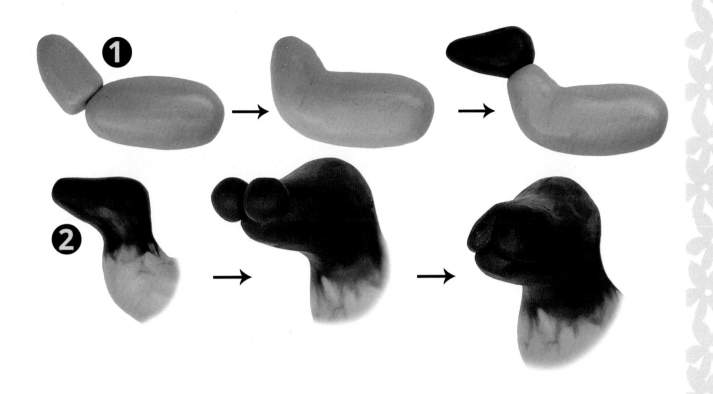

1 Attach the neck to the body then blend the connection.

Attach the head to the top of the neck.

2 Blend the connection between the head and the neck by smearing the head clay towards the neck.

Attach the two cheeks to the front of the snout then blend the connection only on the sides and top.

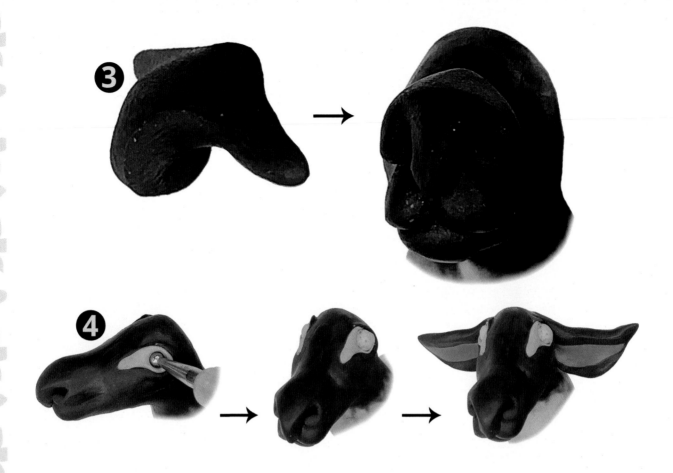

3 Curl all three tips of the nose clay inward then attach the nose to the top of the cheeks.

4 Blend the nose connection towards the middle part of the snout. Make sure to leave the front part of the nose unblended.

Add the eye spots to each side of the head.

Poke a hole in each eye spot with a ball stylus tool then place the eyes in the holes.

Attach the ears to each side of the head then blend the connection on the back side of the ear.

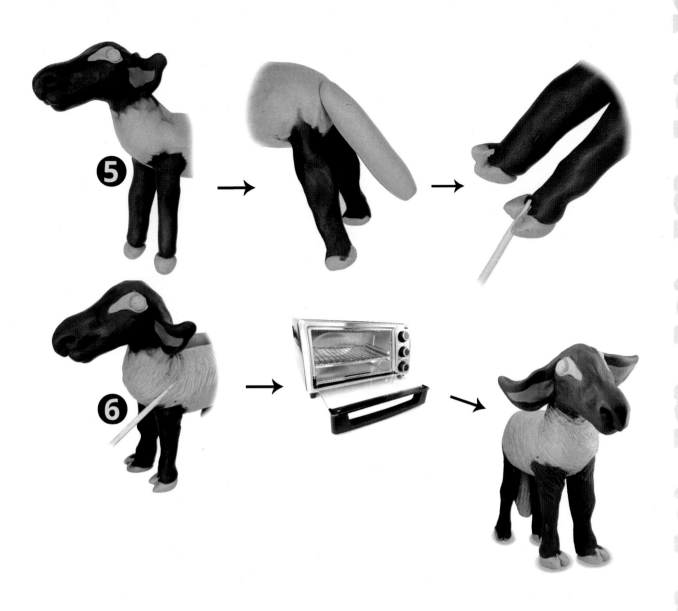

5 Attach the front and hind legs to the body then blend the connection by smearing the legs clay towards the body clay. Attach the tail then blend the connection.

Shape the hooves of the sheep by pressing a toothpick in the middle front part of each foot then form the separation into a point.

6 Texture the body, the top part of the legs, and the tail by scoring lightly in one direction with a toothpick.

Bake the sculpture at 250°F for 20 minutes. Wait until the sculpture cools off before handling to prevent breakage.

Raccoon

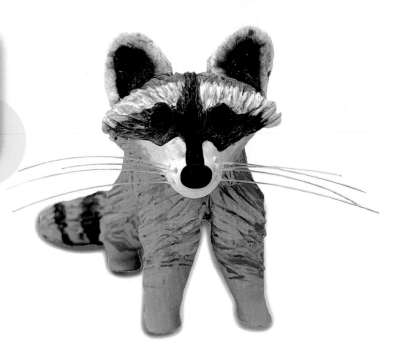

create These forms

You will bake the eyes before adding them to the sculpture. Strictly follow the instructions on the next page.

TOOLS NEEDED:
- Toothpicks and scissors
- Brush and baby oil
- Clear-gel super glue
- Fishing line

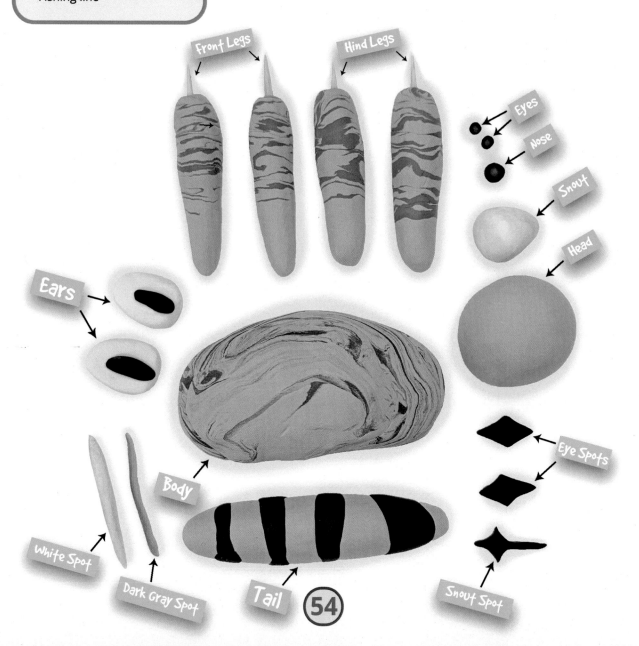

Front Legs

Hind Legs

Eyes

Nose

Snout

Head

Ears

Body

Eye Spots

White Spot

Dark Gray Spot

Tail

Snout Spot

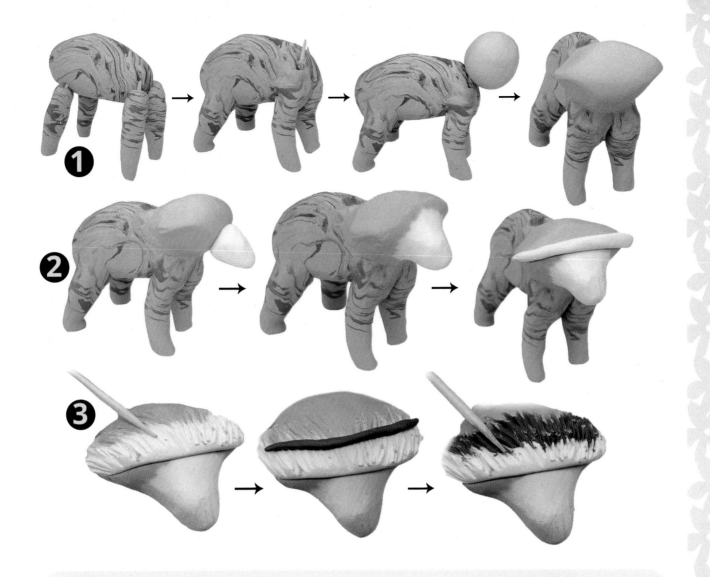

① Attach the front and hind legs to the body then blend the connection by lightly smearing the clay. Form the legs slightly curved.

Attach the head to the front of the chest. Pinch each side of the head to form a pointy oblong shape.

② Blend the connection between the head and body by lightly smearing the head clay towards the body.

Attach the snout to the front of the head and point it slightly downwards. Blend the connection by lightly smearing the snout clay towards the head.

Place the white spot horizontally on top of the border of the snout.

③ Lightly score the white spot towards the top of the head with a toothpick, moving in one direction.

Add the dark gray spot on top of the white spot then lightly score it with a toothpick.

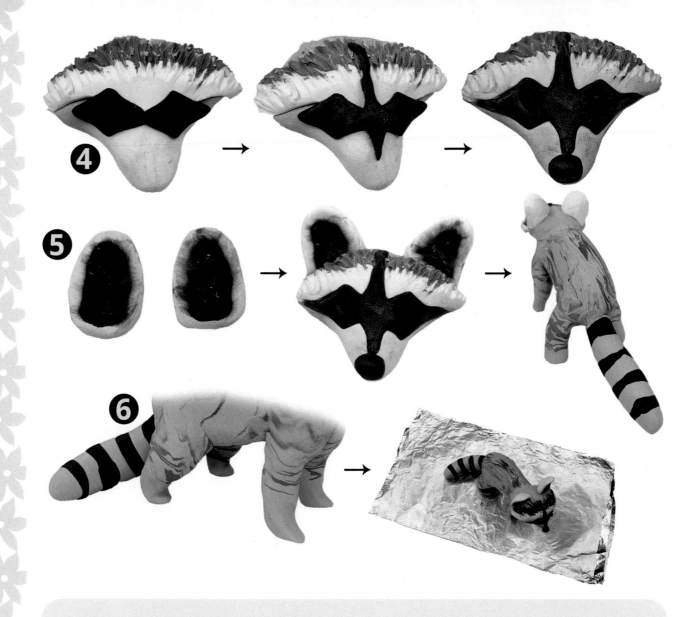

4 Place the two diamond-shaped eye spots on top of the snout side-by-side. Make sure the center points connect. Add the snout spot vertically in the middle of the eye spots. Lightly flatten the eye spots and the snout spot with your finger.

Add and depress the baked eyes in the top middle part of each eye spot. Add the nose.

5 Prepare the ears. Lightly smear the black part of the ears clay outward. Attach the ears to the upper sides of the head.

Attach the layered tail then lightly blend the connection.

6 Form all the legs tips pointed to create the feet.

Place the sculpture on a flat foil platform.

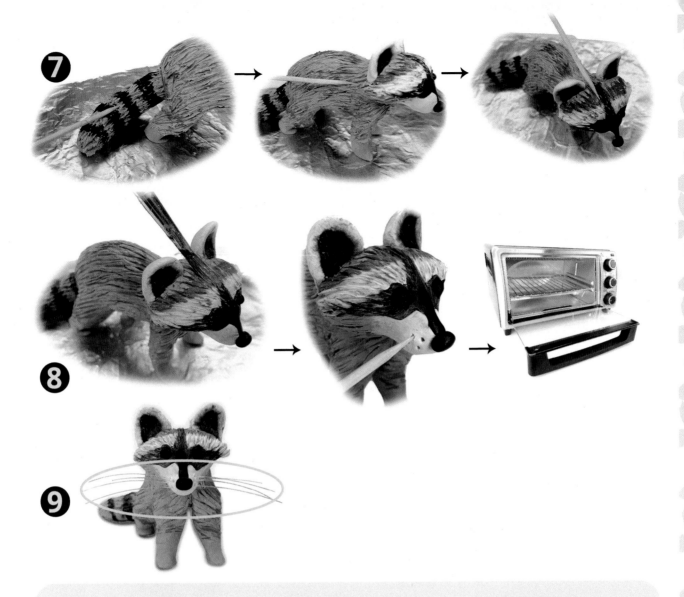

7 Texture the tail by scoring the clay vertically and deeply with a toothpick in one direction. Continue scoring the body, starting at the bottom and hind legs.

Texture the middle body, neck, and front legs with a toothpick.

Texture the top part of the head.

8 Gently smooth the textured area with a brush and small amount of baby oil following along the direction of the scores.

Poke four holes in each side of the cheeks with a toothpick for whisker pores.

Bake the sculpture at 250°F for 20 minutes. Wait until the sculpture cools off before handling to prevent breakage.

9 Lightly dip the tip of each whisker in the clear-gel super glue and place the whisker in the whisker pore. Repeat this process for the remaining seven whiskers. Trim the whiskers with scissors as needed.

Chipmunk

Midbody Spot

Dark Brown Side Spot

Tail

Body

Thigh

Lower Mouth

Cheeks

Ears

Nose

White Eye Spots

Top Head Spot

Head

Eyes

Chest Spot

Front Legs

Black Eye Spots

White Side Spot

Hind Legs

Create These Forms

You will bake the eyes before adding them to the sculpture. Strictly follow the instructions on the next page.

TOOLS NEEDED:

- Toothpicks and scissors
- Brush and baby oil
- Clear-gel super glue
- Fishing line
- Black permanent marker
- Piece of card

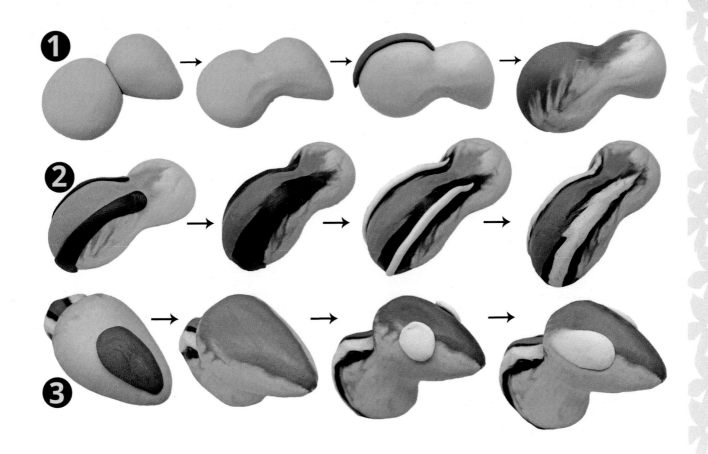

1 Attach the head to the body then blend the connection. Add the midbody spot in the middle back then smear all the edges.

2 Place the two dark brown sidebody spots on the sides of the back then smear the edges.

Place the two white body spots on top of the dark brown sidebody spots then lightly smear the edges.

3 Attach the top head spot on top of the head then smear and spread the clay all over the top of the head.

Place the white eye spots on each side of the head then smear only the back part towards the back.

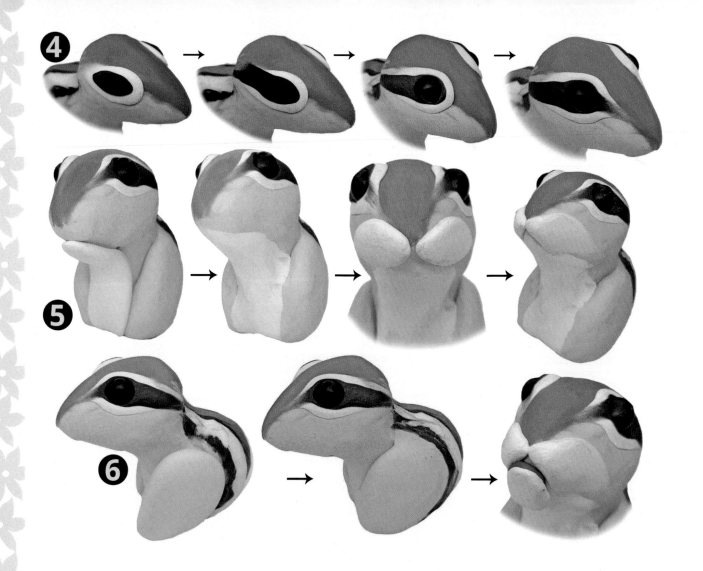

4 Place the black eye spots on top of the white eye spots then smear only the back part towards the back.

Add and depress the baked eyes in the middle of the black eye spots.

Gently smear the corners of both eyes towards the snout.

5 Place the white chest spot in front of the chest then smear the connection.

Place the two white cheeks on the sides of the face then smear the connection only at the back towards the sides of the head.

6 Attach both thighs to the sides of the body then blend only the connection at the back.

Attach the lower mouth under the snout.

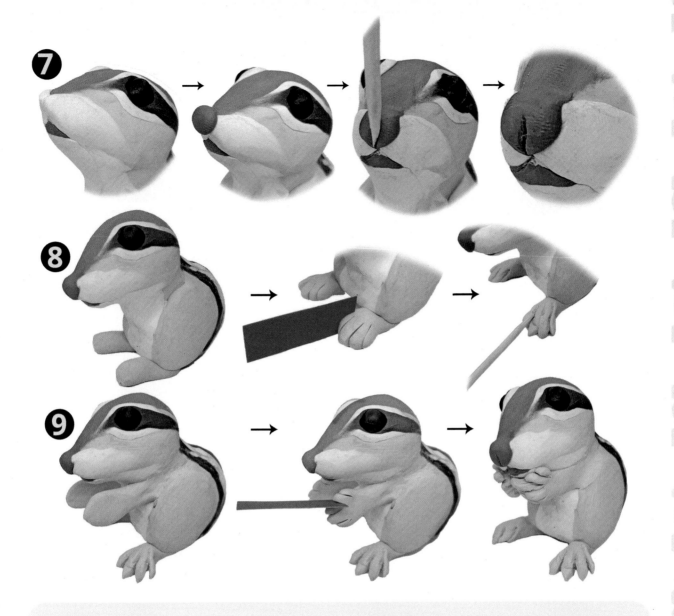

7 Form the whole snout and mouth into a point then add the nose.

Use a toothpick to create one vertical line in the middle of the nose.

8 Attach the two hind legs under the bottom of the chipmunk.

Slice the tips of the hind legs with a card piece tool into four evenly spaced cuts. Form the toes with a toothpick.

9 Attach the front legs to the front sides of the upper body then blend the connections. Pinch both tips of the front legs.

Slice the tips of the front legs with a card piece tool into four evenly spaced cuts. Form the fingers with a toothpick.

Maneuver both hands close to the mouth.

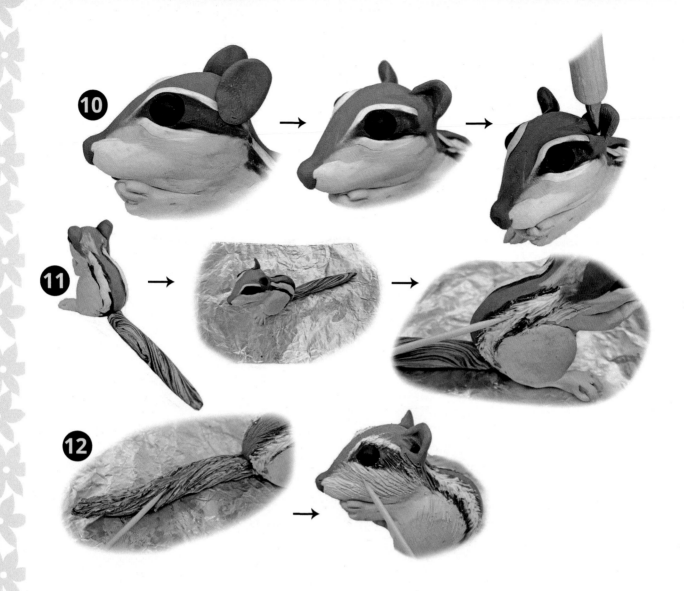

10 Attach the ears to the upper sides of the head then blend the connections. Form each ear concave. Poke holes in the inner ears with a ball stylus tool.

11 Attach the tail to the bottom then lightly blend the connection.

Place the sculpture on a foil platform.

Texture and score the white body spots with a toothpick in diagonal lines.

12 Texture and score the tail diagonally and sideways.

Texture and score the face diagonally from the snout down to the sides of the cheeks.

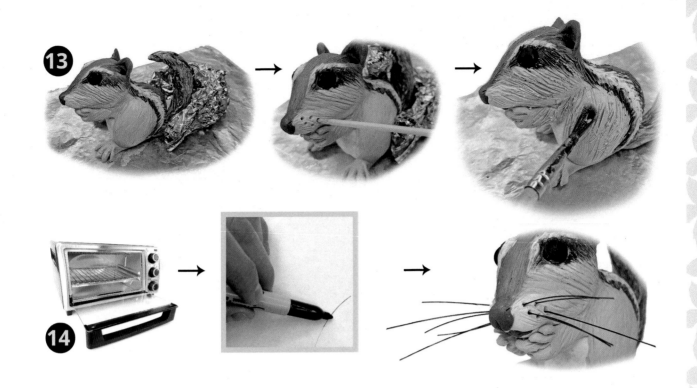

13 Maneuver the tail pointing up then prop it with balls of foil to keep it upright during baking.

Poke five holes on each side of the cheeks with a toothpick to create whisker pores.

Smooth the textures and surfaces with a brush and small amount of baby oil following the direction of the scored lines.

14 Bake the sculpture at 250°F for 20 minutes. Wait until the sculpture cools off before handling to prevent breakage.

Paint or color each fishing line whisker with a black permanent marker.

Lightly dip the tip of each whisker in clear-gel super glue then place them in the whisker pores.

Mandrill

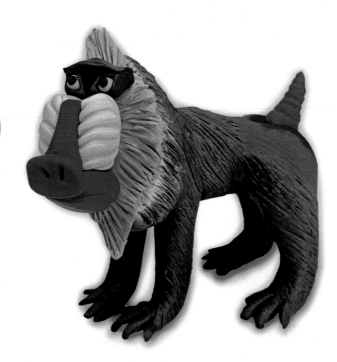

Create These Forms

You will bake the eyes with irises before adding them to the sculpture. Place a hidden toothpick skewer in the hind legs. Strictly follow the instructions on the next page.

TOOLS NEEDED:

- Toothpicks and scissors

- Brush and baby oil

- Piece of card

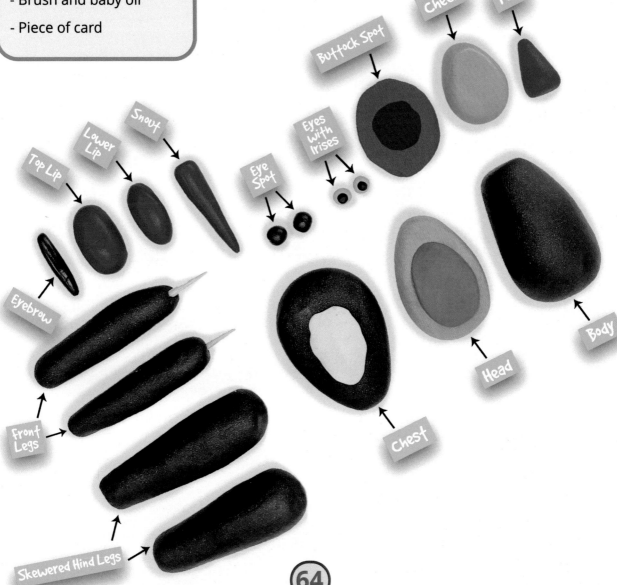

Top Lip

Lower Lip

Snout

Eyebrow

Front Legs

Skewered Hind Legs

Eye Spot

Eyes With Irises

Buttock Spot

Cheek

Tail

Chest

Head

Body

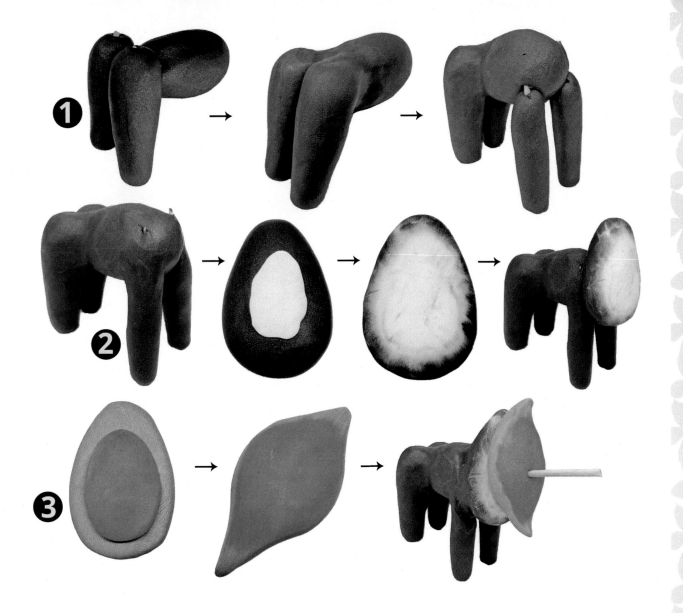

1 Attach the two skewered hind legs to the narrow end of the body then blend the connections.

Attach the two front legs to the bottom front of the body.

2 Blend the connections between the front legs and the body.

Prepare the chest clay. Smear the edges of the inner part of the chest clay then attach it to the front of the body.

3 Prepare the head clay. Smear the edges of the inner part of the head clay. Form the head clay into a lemon shape.

Place the head on top of the chest and insert a toothpick all the way through in the middle to secure the clay pieces in place.

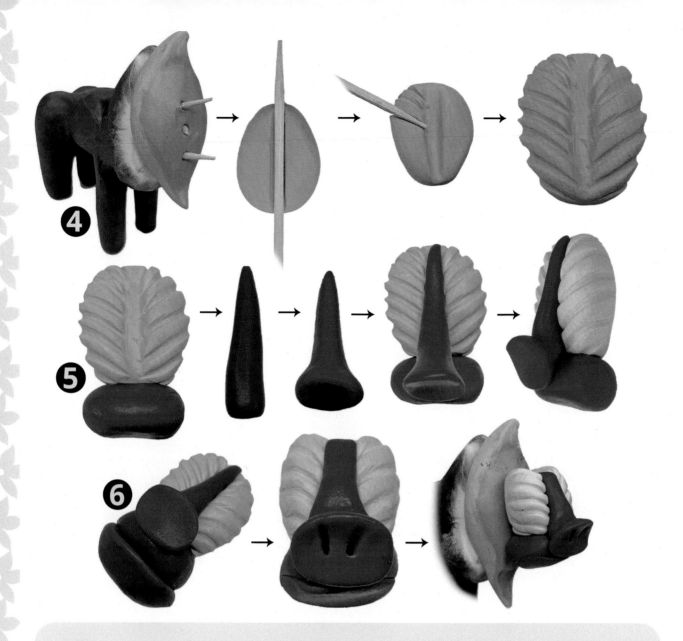

4 Take another toothpick and cut it in half with scissors. Insert the toothpick pieces in the head above and below the first toothpick, keeping the toothpick tips exposed.

Prepare the cheek clay. Create a vertical indentation by pressing a toothpick in the middle of the cheek clay. Create diagonal and upward indentations on both sides of the cheek clay with a toothpick.

5 Place the top lip right below the cheek.

Prepare the snout clay. Pinch and press the bottom of the snout to create a flat surface then place the snout in the middle of the cheek. Press the bottom part of the snout clay upward.

6 Add the lower lip.

Poke two holes in the middle of the snout to create the nostrils. Attach the entire face formation to the head.

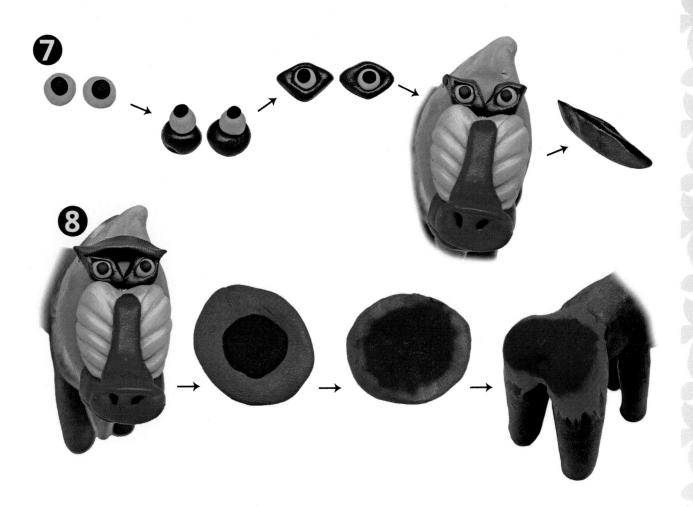

7 Prepare the baked eyes with irises.

Place each baked eye on top of an eye spot.

Depress the eyes in the eye spots then form both eyes spots into a diamond shape.

Place both eyes formations on top of the mandrill's face.

Prepare the eyebrow clay. Pinch the front part of the eyebrow.

8 Place the eyebrow on top of the eyes then blend the connections only on the sides.

Prepare the buttocks spot clay.

Smear the edges of the inner part of the buttocks clay.

Place the buttocks clay on the buttocks then smear all the edges to the body.

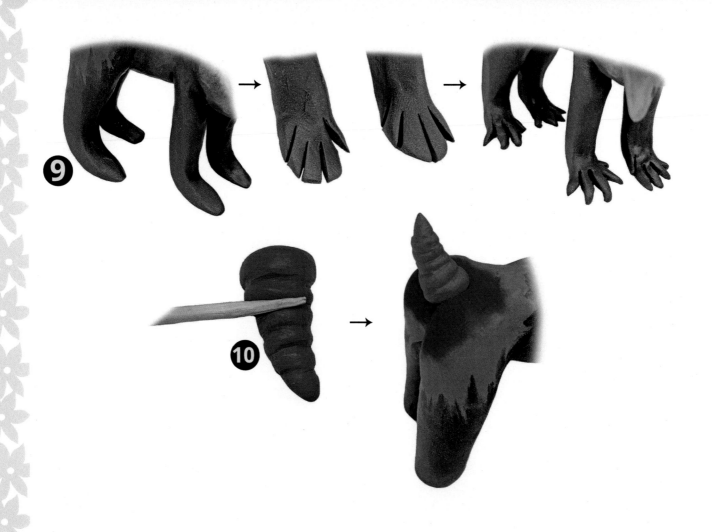

9 Curve all the feet forward.

Create toes and fingers by slicing four evenly spaced cuts with a piece of card. Separate all the fingers and toes then form them thin and rounded.

10 Prepare the tail clay.

Create horizontal indentations around the tail clay by pressing down with a toothpick.

Attach the tail to the middle of the buttocks area.

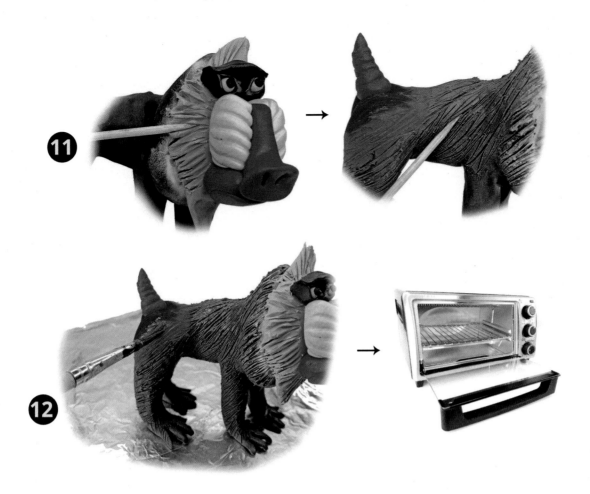

11 Texture the head by scoring the surface with a toothpick.

Continue texturing the body and legs.

12 Place the sculpture on a foil platform.

Smooth the surface of the sculpture with a brush and small amount of baby oil.

Bake the sculpture at 250°F for 20 minutes. Wait until the sculpture cools off before handling to prevent breakage.

Tiger

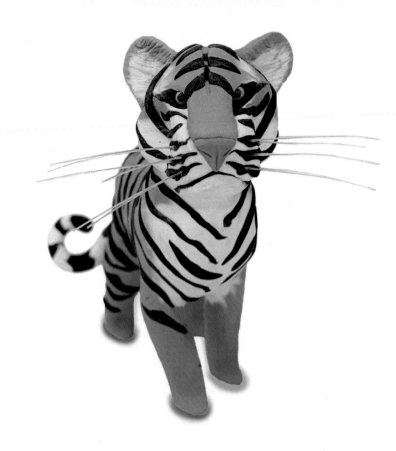

create These forms

You will bake the eyes with irises before adding them to the sculpture. Strictly follow the instructions on the next page.

TOOLS NEEDED:
- Toothpicks and scissors
- Brush and baby oil
- Clear-gel super glue
- Fishing line

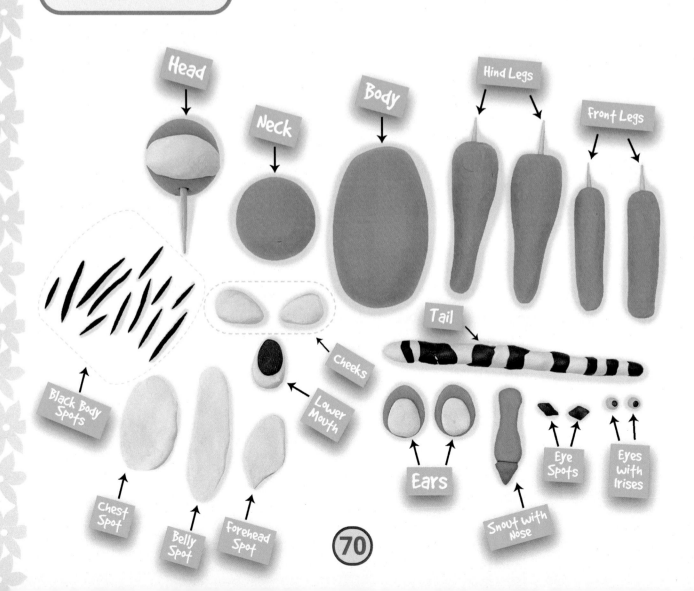

Head

Neck

Body

Hind Legs

front Legs

Tail

Cheeks

Black Body Spots

Lower Mouth

Chest Spot

Belly Spot

forehead Spot

Ears

Snout with Nose

Eye Spots

Eyes with Irises

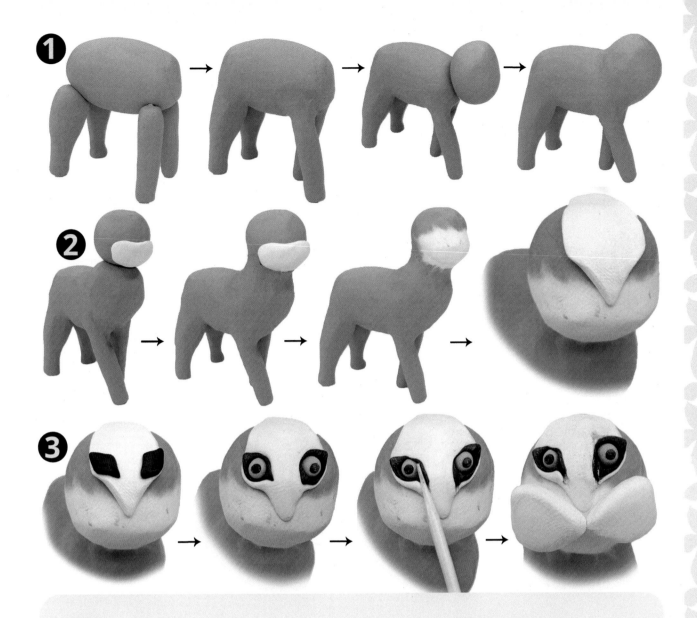

1 Attach the front and hind legs to the body then blend the connections.

Attach the neck to the front of the chest area then blend the connection.

2 Attach the head on top of the neck then blend the connection.

Lightly smear the edges of the white clay on the head.

Place the forehead spot pointing downwards on the front of the head.

3 Place the two eye spots on the front of the forehead spot.

Add the baked eyes with irises to each eye spot.

Score the inner parts of the eye spots downwards with a toothpick to create the eye corners. Attach the cheeks in front of the snout.

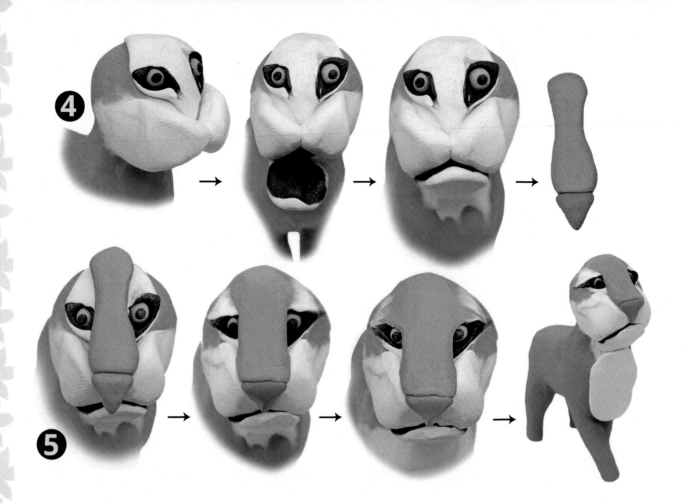

4 Smear the edges of the cheeks only on the sides of the head.

Add the lower mouth under the snout then press to flatten it. Smear the connection only towards the neck.

Prepare the snout with nose clay.

5 Place the snout with nose clay vertically and pointing downward on the front of the face. Press the nose clay inward to adhere.

Smear the edges of the snout only at the top until the beige color is covering the entire top of the head and eyebrows.

Attach the chest spot to the front of the chest.

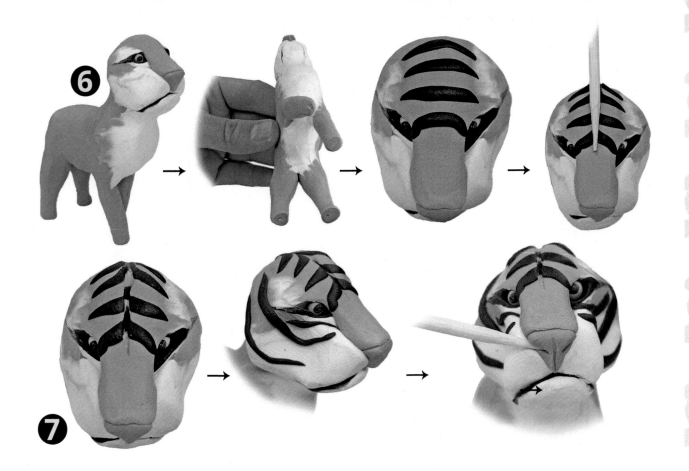

6 Smear the edges of the chest spot.

Add the belly spot to the belly area then smear the edges.

Place four body spots horizontally on top of the head. Score one long vertical line at the middle top of the head with a toothpick.

7 Add more black spots to each side of the head.

Score one vertical line in the middle of the nose clay and a diagonal upward line on each side of the nose with a toothpick. This will create the nostrils.

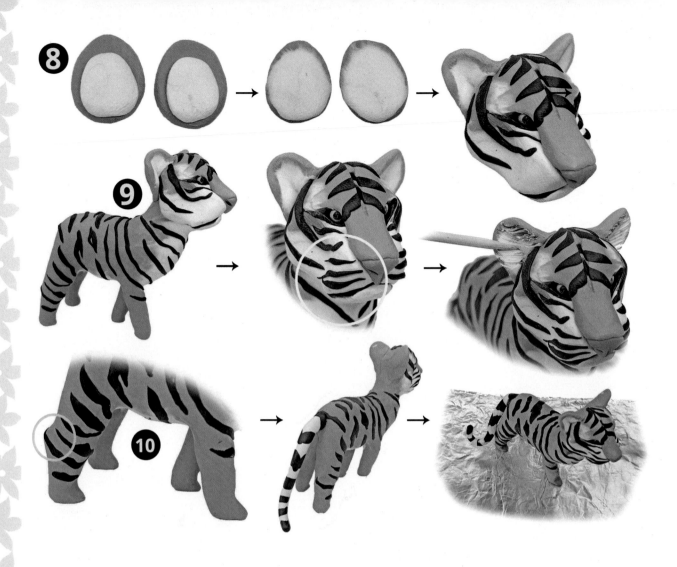

8 Prepare the ears clay. Smear the edges of the white clay.

Attach the ears to the upper sides of the head then blend the connections at the back.

9 Continue to add more black body spots on the entire body in a horizontal pattern.

Add thin pieces of black spots on the cheeks.

Texture the inner part of both ears by scoring with a toothpick.

10 Form the tips of the feet pointed. Pinch the back part of the hind legs to form the hocks.

Attach the tail to the buttocks area.

Place the sculpture on a foil platform.

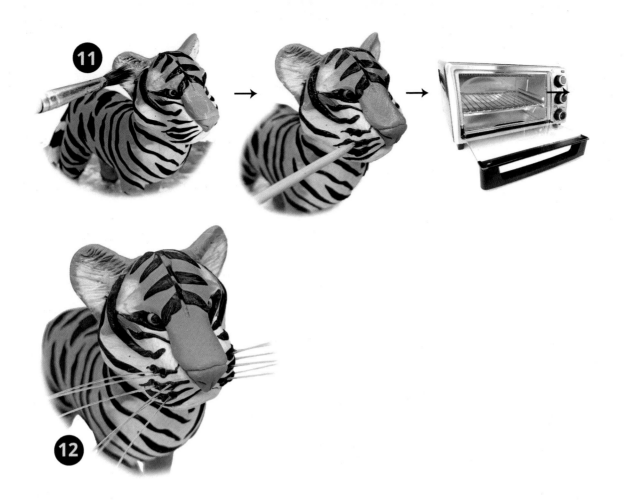

11 Smooth the surface of the sculpture with a brush and small amount of baby oil.

Poke six small holes on the black spots on both sides of the cheeks with a toothpick to create the whisker pores.

Bake the sculpture at 250°F for 20 minutes. Wait until the sculpture cools off before handling to prevent breakage.

12 Dip the small tip of the fishing line in clear-gel super glue then place it immediately inside the whisker pore.

Trim all the whiskers after the glue dries.

Vampire Bat

create These forms

You will bake the eyes before adding them to the sculpture. Strictly follow the instructions on the next page.

TOOLS NEEDED:

- Several pieces of card

- Brush and baby oil

- Toothpick and scissors

- Small ball of aluminum foil

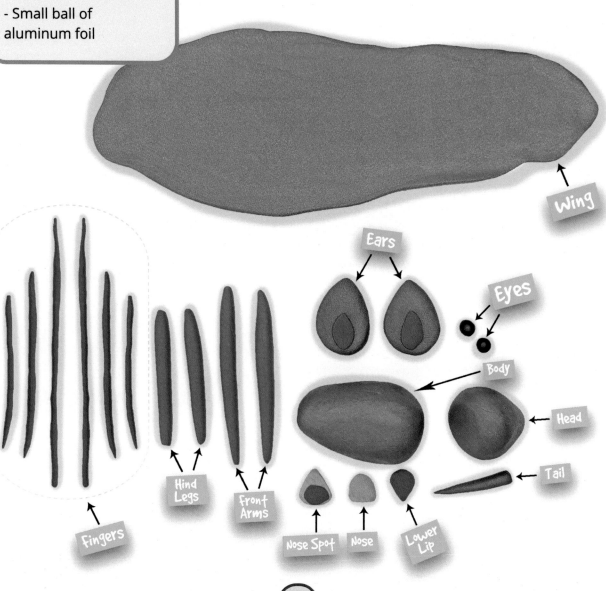

Wing

Ears

Eyes

Body

Head

Tail

Fingers

Hind Legs

Front Arms

Nose Spot

Nose

Lower Lip

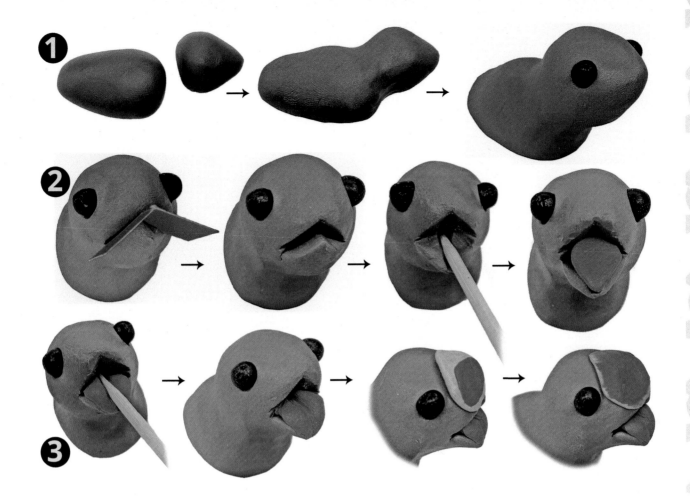

1 Prepare the body and head clay. Connect the head to the body then blend the connection.

Add the baked eyes on each side of the head.

2 Form the mouth by pressing a card tent tool into the head. Open the mouth with a toothpick.

Add the lower lip inside the lower mouth.

3 Create one indentation on the lower lip by pressing a line with a toothpick.

Place the nose spot to the front of the face pointing upwards. Lightly smear the edges of the inner part of the nose spot.

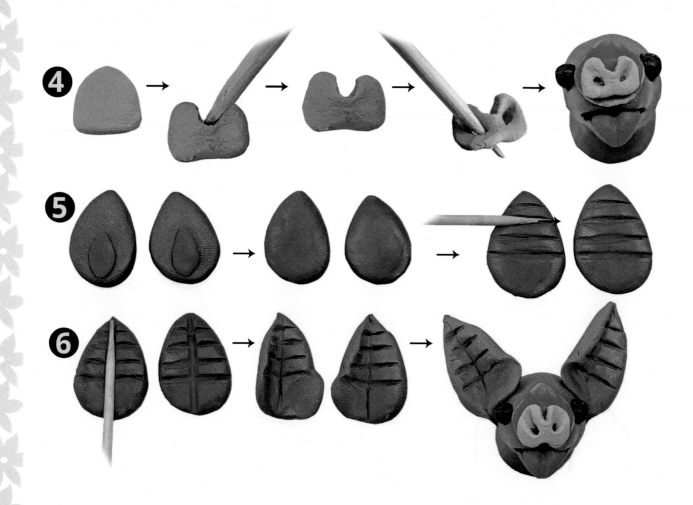

④ Prepare the nose clay. Press the middle top part of the nose clay with a toothpick.

Poke two holes through the clay on each side of the nose with a toothpick.

Place the newly formed nose on the front of the nose spots.

⑤ Prepare the ears clay. Smear the edges of the inner clay.

Create horizontal indentations on the inner ears by pressing with a toothpick.

⑥ Create one long vertical indentation in the middle part of each ear with a toothpick.

Pinch the inner bottom side of the each ear then form the tips pointed.

Attach the newly formed ears to the upper sides of the head then blend the connections.

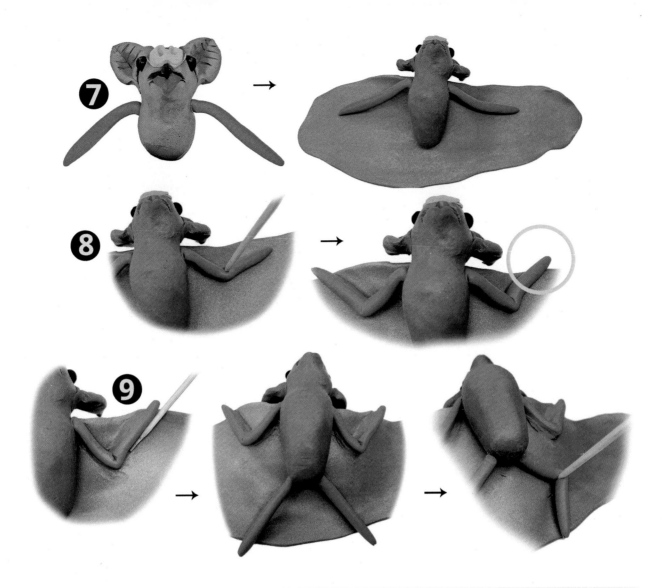

7 Attach the front arms to the upper sides of the body.

Place the whole body with attached front arms on top of the wing clay. **Note: Place a small ball of aluminum foil underneath the back neck of the bat to retain the form of the erect ears.**

8 Bend the front arms in the middle with a toothpick. Make sure the tips of the front arms are exposed beyond the edge of the wing.

9 Smear the connection between the front arms and the wing with a toothpick.

Attach the two hind legs at the bottom of the body.

Bend the hind legs in the middle with a toothpick.

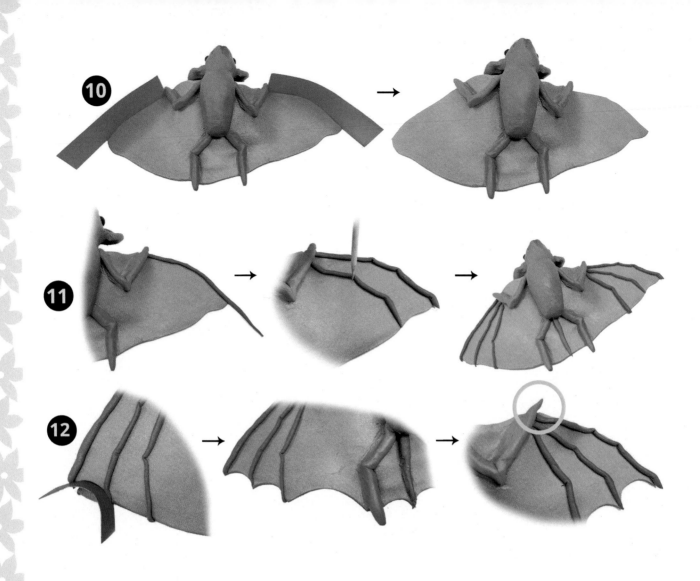

10 Trim the upper part of the wing with two long pieces of card.
Remove the excess clay from the top.

11 Place the longest finger clay on the top outer edge of the wing.
Continue adding more fingers below it. Create three tip points
on the first finger with a toothpick. Create two tip points on the
second finger then create one tip point on the third finger.

Repeat the process of adding the fingers on the other side of
the wing.

12 Slice half-moon forms on the bottom part of the wing with a
small curved piece of card. Remove the excess clay from the
bottom.

Make sure the tip of the front arms is pointed.

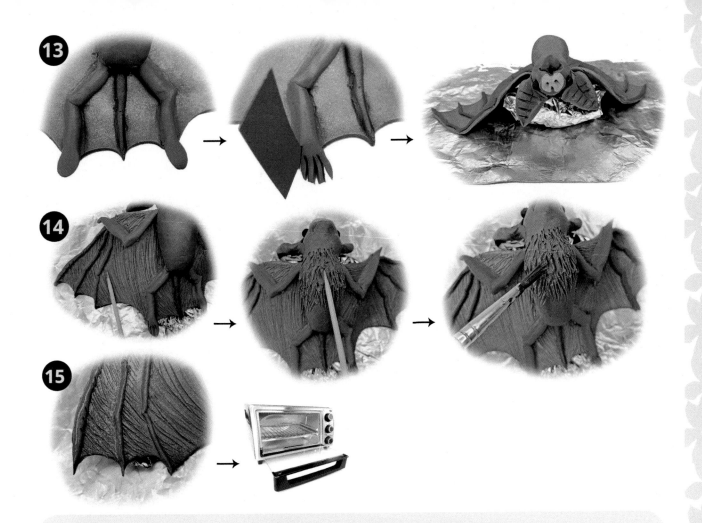

13 Add the tail in between the hind legs then smear the connection between the tail and the wing with a toothpick.

Pinch both end tips of the hind legs.

Create toes by slicing the clay into four evenly spaced lines with a piece of card.

Prepare the sculpture on a foil platform. Place the sculpture on its back on a large ball of aluminum foil. **Note: This will keep the head and wings upright when facing up.**

14 Texture all the inner wings by scoring long vertical lines with a toothpick.

Texture the chest area by scoring deep lines with a toothpick.

Smooth the entire surface of the bat with a brush and small amount of baby oil.

15 Make sure to form all the tips of the fingers pointed.

Bake the sculpture at 250°F for 20 minutes. Wait until the sculpture cools off before handling to prevent breakage.

Warthog

create These forms

You will bake the eyes and all the tusks before adding them to the sculpture. Strictly follow the instructions on the next page.

TOOLS NEEDED:
- Toothpicks and scissors
- Brush and baby oil
- Dark brown yarn
- Clear-gel super glue
- Piece of card
- Medium-sized ball stylus tool

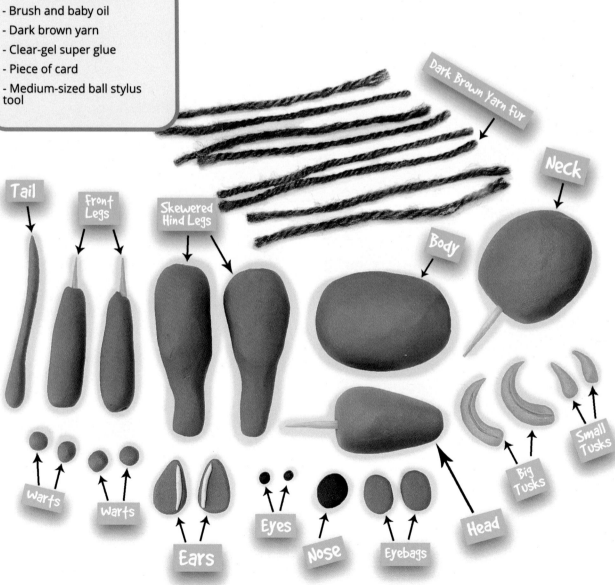

Tail

Front Legs

Skewered Hind Legs

Dark Brown Yarn Fur

Neck

Body

Warts

Warts

Ears

Eyes

Nose

Eyebags

Head

Big Tusks

Small Tusks

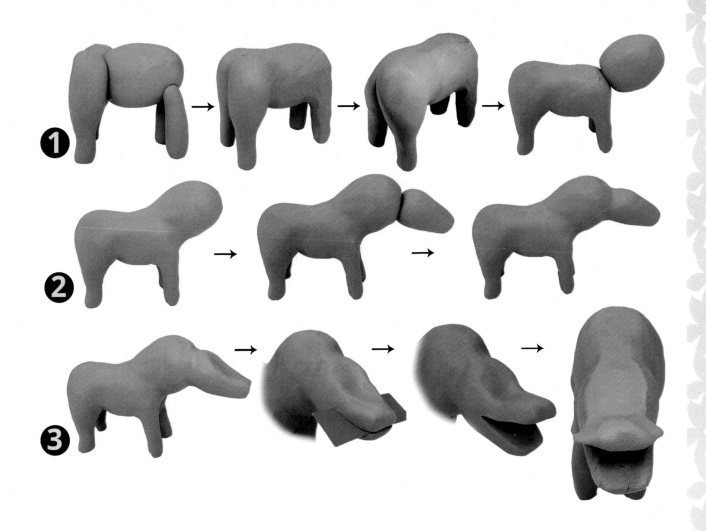

❶ Attach the skewered hind legs to the bottom side of the buttocks. Add the front legs. Blend all the connections.

Lightly pinch the bottom side of the buttocks to narrow its form.

Attach the neck to the chest area.

❷ Blend the connection between the neck and body.

Attach the head to the front of the neck then blend the connection.

❸ Press to flatten the top part of the head with your fingertip.

Create the mouth by slicing the snout horizontally with a piece of card. Open the mouth.

Pinch each side of the top mouth to create the lips.

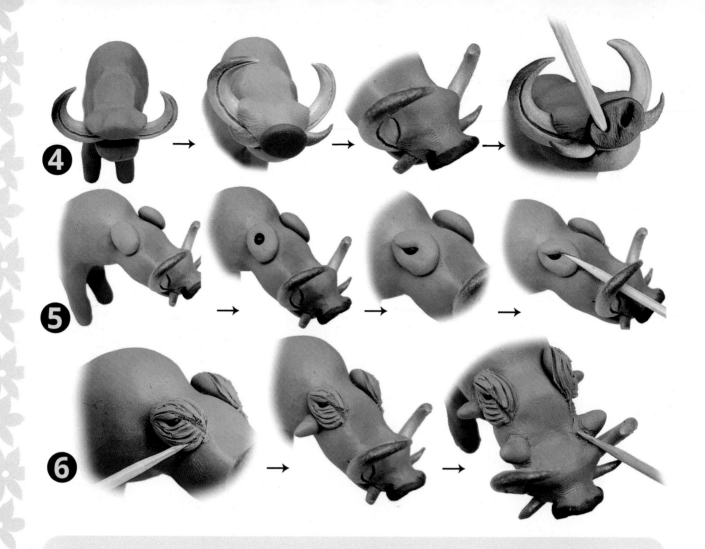

4 Add the baked big tusks to each side of the mouth.

Add the baked small tusks right in front of the big tusks. Make sure to press the top lips to secure all the tusks in place.

Add the nose in front of the snout then lightly pinch the edges of the nose.

Poke two holes in the front of the nose with a toothpick to create nostrils.

5 Add the eyebags to each side of the head.

Add and depress the baked eyes in the middle of each eyebag. Press the top part of the eyebag to lightly close the upper lids. Score a line in front of the eyes with a toothpick to create the eye corners.

6 Score the eyebags with a toothpick, forming lines surrounding the eyes.

Attach a wart to each side of the head right below the eyebags then attach a wart on each side of the snout. Blend all the warts connections to the head with a toothpick.

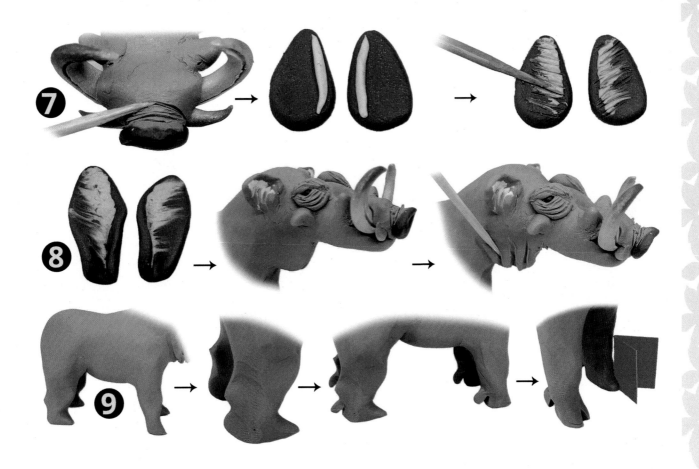

7 Texture the top part of the nose in horizontal lines with a toothpick.

Prepare the ears clay. Score the inner white part of the clay horizontally and upward with a toothpick.

8 Curl the inner bottom ears inward.

Attach the ears to each side of the head then blend the connections.

Pinch the bottom part of the neck to create a neck flap.

Create indentations on the neck flap with a toothpick.

9 Form all the tips of the feet pointed. Pinch the back of the hind legs and the back of the feet to create hocks.

Slice a line in the middle of each foot with a card tent tool.

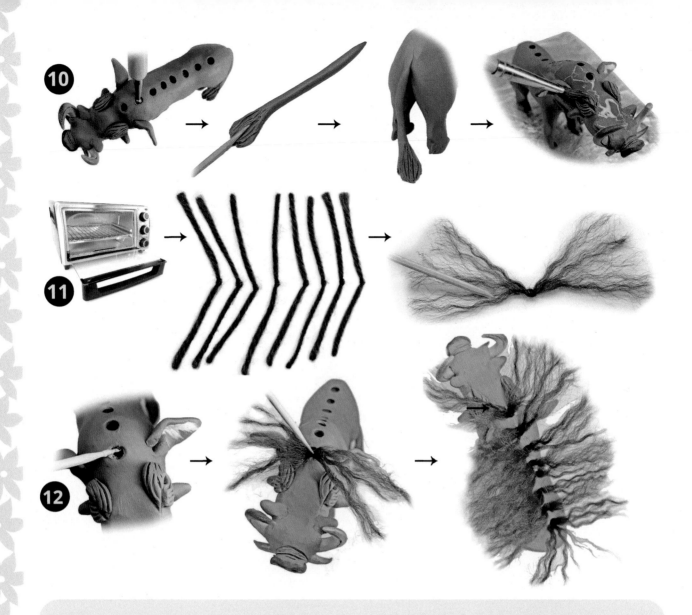

10 Poke 8 holes on the back of the warthog with a medium-sized ball stylus tool. This will create the yarn fur pores.

Texture one end tip of the tail by scoring it with a toothpick then attach the tail to the buttocks. Blend the connection.

Place the sculpture on a foil platform then smooth the surface with a brush and small amount of baby oil.

11 Bake the sculpture at 250°F for 20 minutes. Wait until the sculpture cools off before handling to prevent breakage.

Prepare the 8 pieces of dark brown yarn fur. Make a knot in the middle of each yarn fur. Comb the yarn fur with a toothpick.

12 Apply a small amount of clear-gel super glue in one hole of the head then insert the knot of one dark brown yarn fur in the hole with a toothpick. Repeat this process for all the holes and dark brown yarn fur on the back.

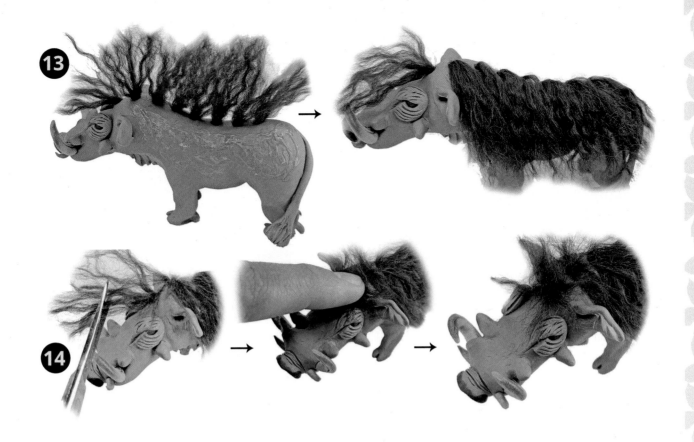

13　Apply dabs of clear-gel super glue on one side of the body then flatten the yarn fur to secure it in place. Leave one yarn fur in front unglued for the bangs.

14　Trim the front yarn fur with scissors.

Press and swirl the bangs with a fingertip to create a puffy look.

COW

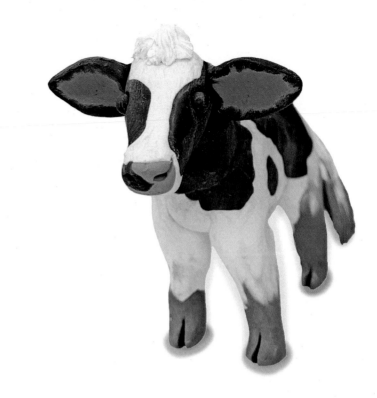

Create These Forms

You will bake the eyes before adding them to the sculpture. The hind legs have hidden toothpick skewers in them. Strictly follow the instructions on the next page.

TOOLS NEEDED:
- Toothpicks and scissors
- Brush and baby oil
- Piece of card
- Medium-sized ball stylus tool

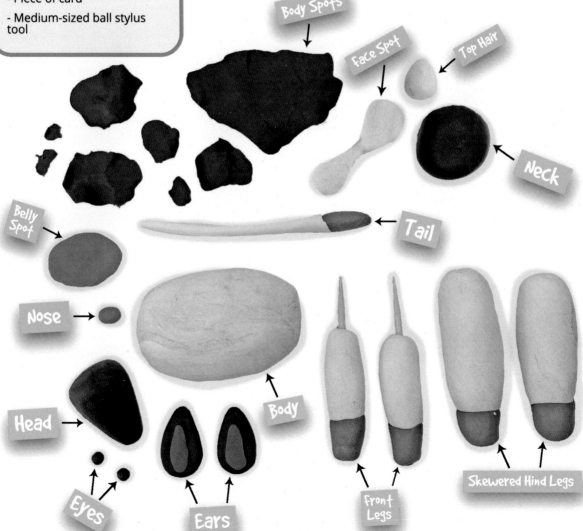

Body Spots

Face Spot

Top Hair

Neck

Belly Spot

Tail

Nose

Head

Body

Eyes

Ears

Front Legs

Skewered Hind Legs

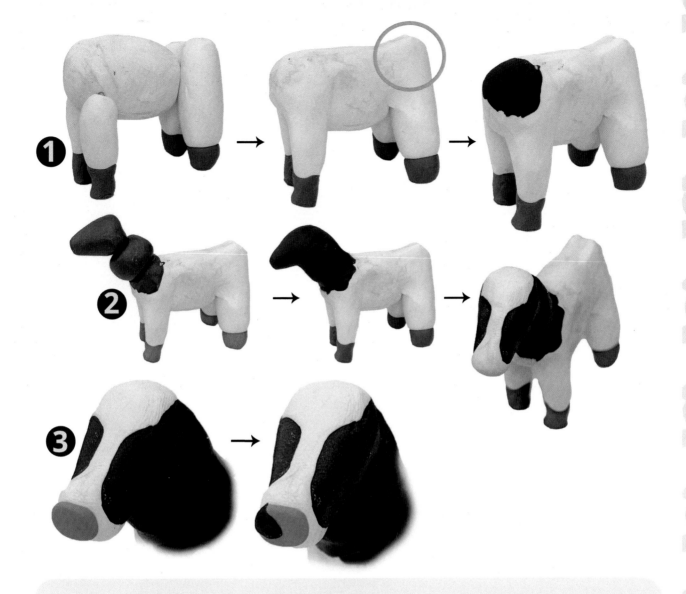

1 Attach the front legs to the lower front sides of the body.

Attach the hidden skewered hind legs to the outer side of the buttocks. Blend the connections. Make sure that the buttocks part is raised upright.

Attach one black body spot to the neck area.

2 Attach the neck to the front of the chest, then attach the head to the front of the neck. Blend all the connections.

Add the white face spot vertically to the front of the head. Extend the bottom of the face spot to cover the entire front snout.

3 Form the nose clay into a flattened oblong shape then place it horizontally on the front of the snout. Add one small black body spot to the nose.

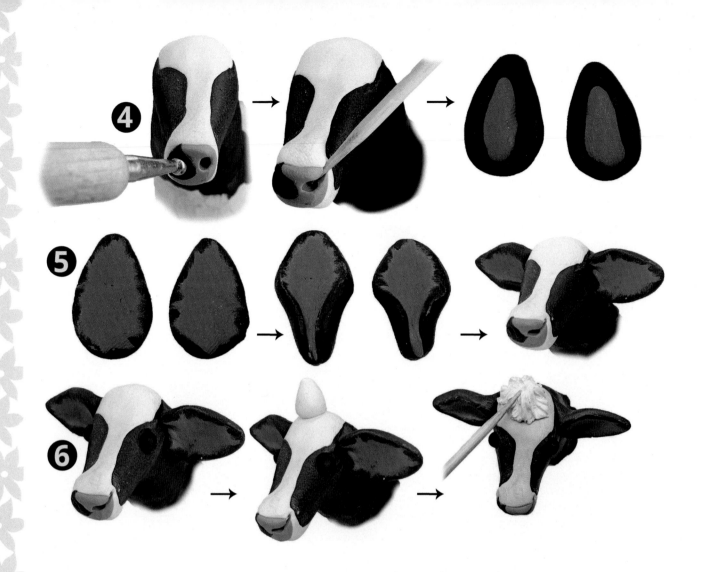

4 Poke two holes in the front of the nose with a medium-sized ball stylus tool to create the nostrils. Score the upper side of each nostril with a toothpick.

Prepare the ears clay.

5 Lightly smear the edges of the inner part of the ears.

Curl the bottom side of each ear inwards.

Attach an ear facing forward and pointing sideways on each side of the head then blend the connection.

6 Attach the baked eyes to the sides of the head.

Add the top hair clay on top of the head then score it with a toothpick downwards.

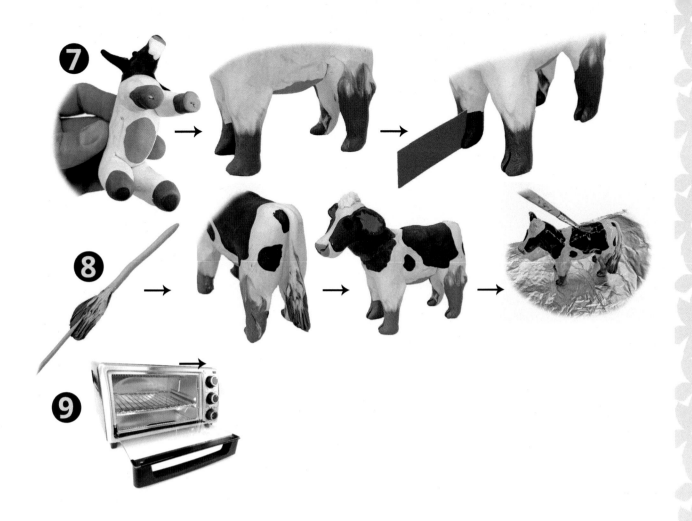

7 Attach the pink belly spot to the belly area.

Smear the dark gray bottom part of all the legs upwards. Form the feet pointed.

Slice one line in the middle of each foot with a piece of card.

8 Flatten the tip of the tail then texture it by scoring with a toothpick.

Add more black body spots to the body and buttocks area. Attach the tail to the buttocks area then blend the connection.

Make sure that the cow is stable standing upright on all legs.

Place the sculpture on a foil platform then smooth the surface with a brush and small amount of baby oil.

9 Bake the sculpture at 250°F for 20 minutes. Wait until the sculpture cools off before handling to prevent breakage.

Elk

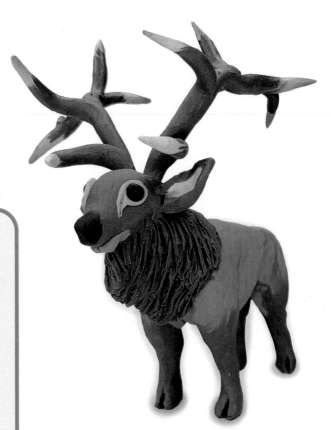

create These forms

You will bake the eyes before adding them to the sculpture. Place a hidden toothpick skewer in each hind leg. Strictly follow the instructions on the next page.

TOOLS NEEDED:
- Toothpicks and scissors
- Brush and baby oil
- Piece of card
- Small balls of aluminum foil
- Small-sized ball stylus tool

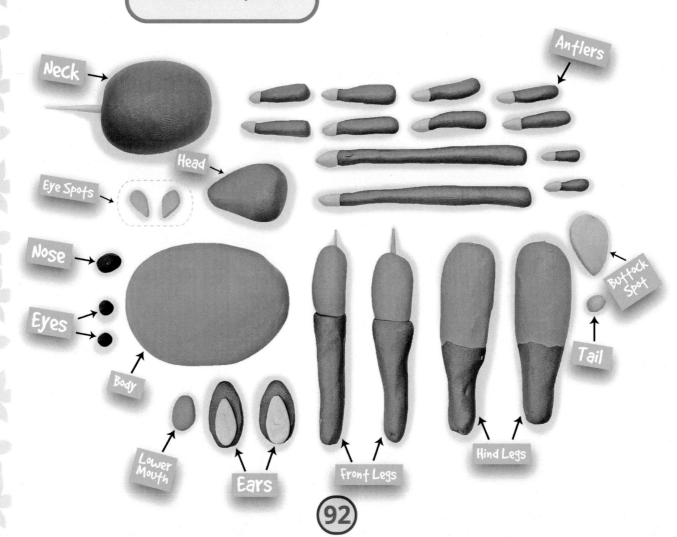

Neck

Antlers

Head

Eye Spots

Nose

Eyes

Body

Lower Mouth

Ears

Front Legs

Hind Legs

Tail

Buttock Spot

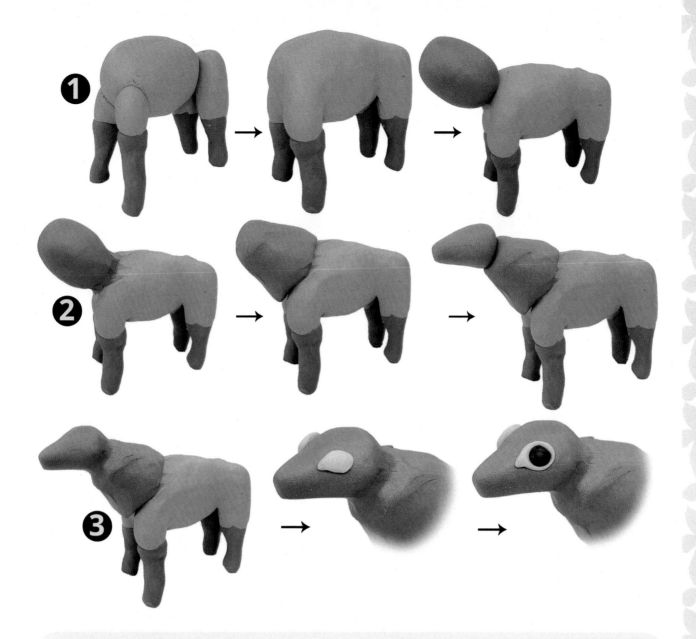

❶ Attach the two front legs to the lower front of the body. Attach the two hind legs at the back of the body. Blend all the connections.

Attach the neck at a diagonal to the front of the neck area.

❷ Lightly smear the neck connection to the body. Press and form the oblong-shaped neck into a rounded cone shape.

Attach the head to the front of the neck.

❸ Blend the connection between the head and the neck.

Place the two eye spots on the sides of the head.

Place and depress each baked eye in the middle of each eye spot.

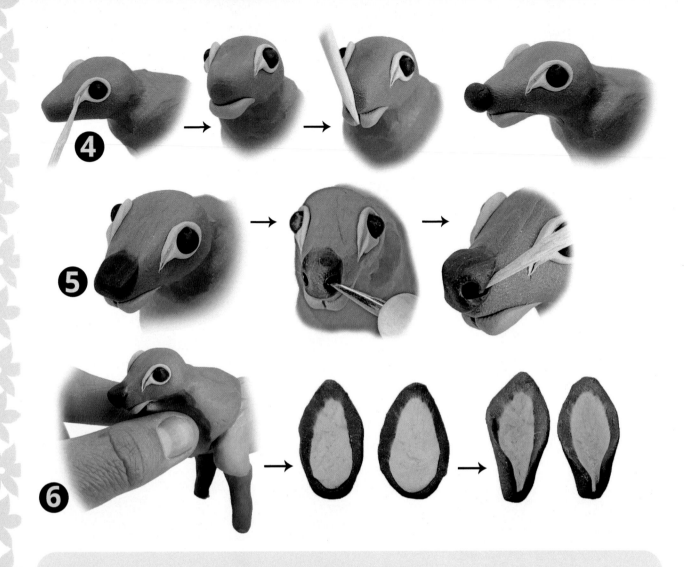

4 Score a line downward in the inner part of both eye spots to create the eye corners.

Place the lower mouth under the snout then lightly smear only the bottom part towards the neck. Create a vertical indentation on the middle of the lower mouth with a toothpick.

Add the nose.

5 Lightly smear the nose only at the top towards the upper snout.

Poke two holes in each front side of the nose to create the nostrils. Score a line on each side of the nose with a toothpick.

6 Pinch the front part of the neck.

Prepare the ears. Lightly smear the edges of the inner part of the ear. Curl the bottom part of the ears inward.

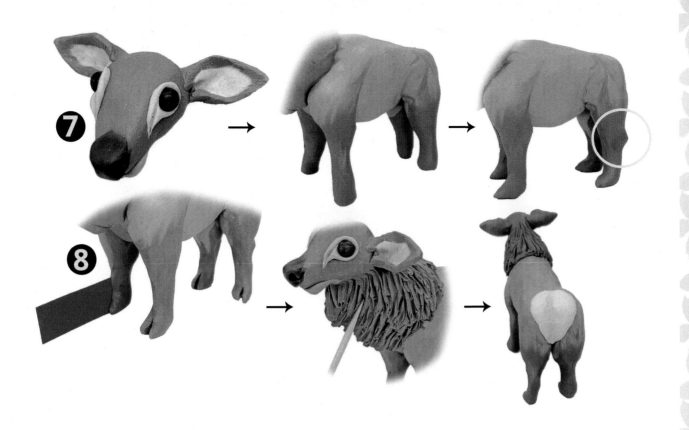

7 Attach the ears to the sides of the head pointing sideways then blend the connections.

Smear the dark brown clay upwards on all the legs.

Form each feet pointed and pinch the clay on the hind legs to create the hocks.

8 Slice one line in the front of each foot with a piece of card.

Texture the neck with a toothpick in deep scores downward. This will create the scruff of the elk.

Place the buttock spot on the buttocks area then lightly press and flatten it with a finger.

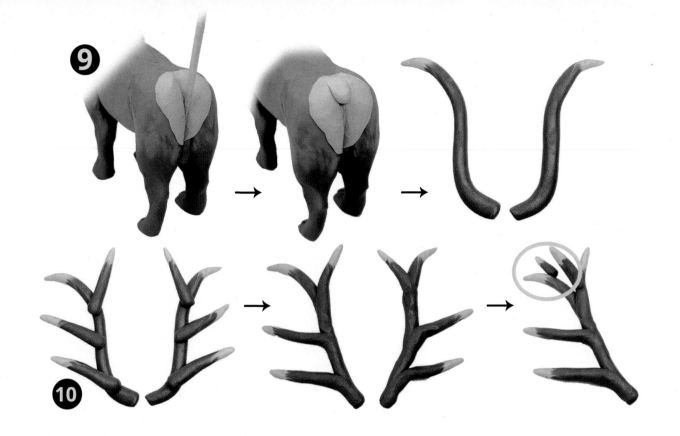

9 Create an indentation in between the buttocks with a toothpick.
Add the tail.
Prepare the two longest antlers. Form each antler curved.

10 Add three smaller antler pieces pointing outwards on each of the longest antlers then blend the connections. Add the two smallest antler pieces at the top of each antler.

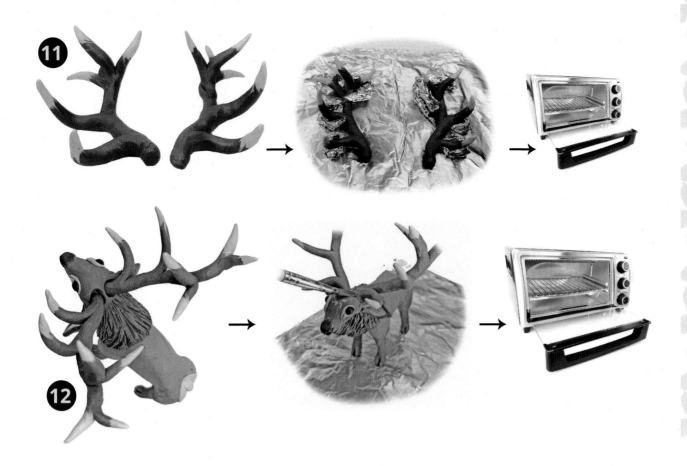

11 Form all the antlers curving upwards. Prepare the two newly formed antlers on a foil platform then prop each small antler piece with small balls of aluminum foil. This will help all the antlers retain their form during baking.

Bake the antlers at 250°F for 3 minutes. Wait until the sculpture cools off before handling to prevent breakage.

12 Once the baked antlers have cooled off, insert each antler deeply into the top of the elk's head then blend the connections with a toothpick. This will close any gaps around the antlers' base.

Place the elk sculpture on a foil platform. Make sure that all the body parts are stable. Use balls of aluminum foil to create stability.

Smooth the surface of the unbaked sculpture with a brush and small amount of baby oil.

Bake the sculpture at 250°F for 20 minutes. Wait until the sculpture cools off before handling to prevent breakage.

Floppy-eared Rabbit

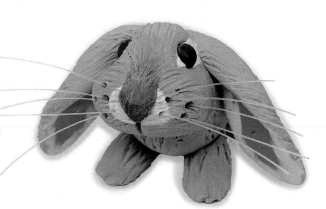

create These forms

You will bake the eyes before adding them to the sculpture. Strictly follow the instructions on the next page.

TOOLS NEEDED:
- Toothpick and scissors
- Brush and baby oil
- Clear-gel super glue
- Fishing line

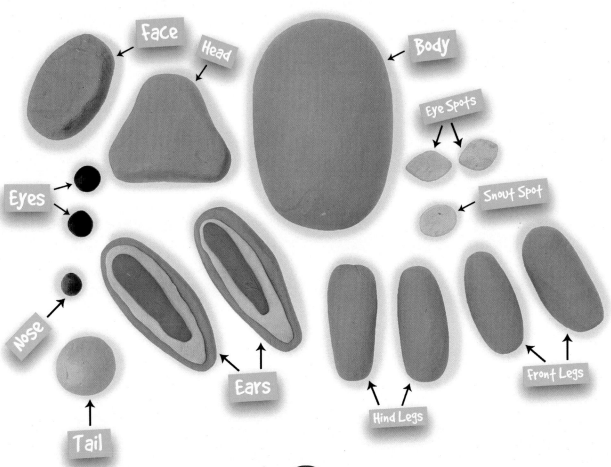

Face

Head

Body

Eye Spots

Eyes

Snout Spot

Nose

Ears

Front Legs

Hind Legs

Tail

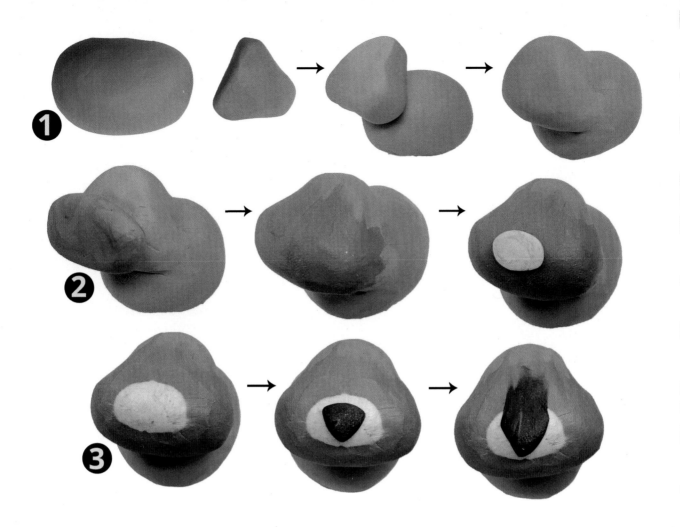

❶ Attach the head to the front top of the body then blend the connection. Make sure to retain a rectangular head shape with rounded edges.

❷ Attach the face horizontally to the front of the head then blend the connection by smearing the face clay towards the head. Attach the snout spot horizontally to the front of the face.

❸ Lightly smear the edges of the snout spot towards the face.

Form the nose into a triangular shape then attach it in an inverted position to the front of the snout. Gently smear only the top part of the nose towards the forehead.

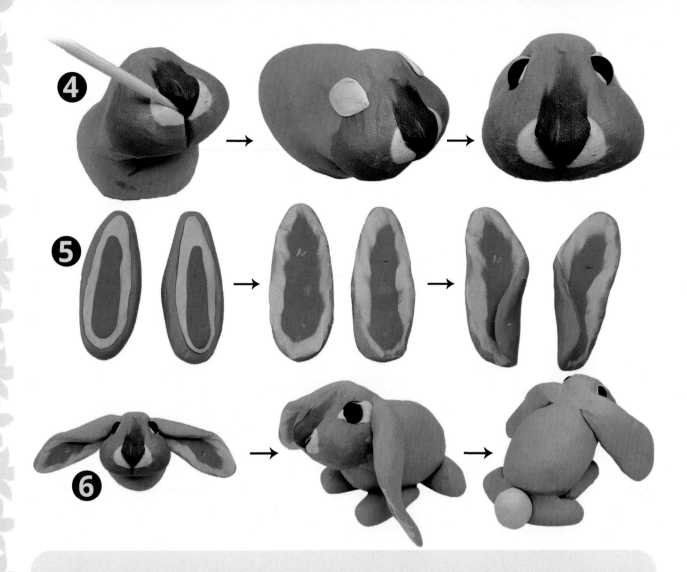

4 Use a toothpick to create a vertical indentation at the middle part of the cheeks right below the nose. Create an indentation in between the nose and the cheek for both sides.

Place the eye spots on each side of the upper head where the eyes will be placed.

Add and depress the baked eyes in the middle of each eye spot.

5 Prepare the ears clay. Lightly smear the edges of all the different colored clay. Curl the bottom part of each ear clay inwards.

6 Place an ear on each side of the head with the inner curves at the top. Blend the connections at the back.

Attach the two front legs at the bottom of the chest and attach the two hind legs sticking outward below the buttocks. Blend the connections.

Add the tail to the buttocks area.

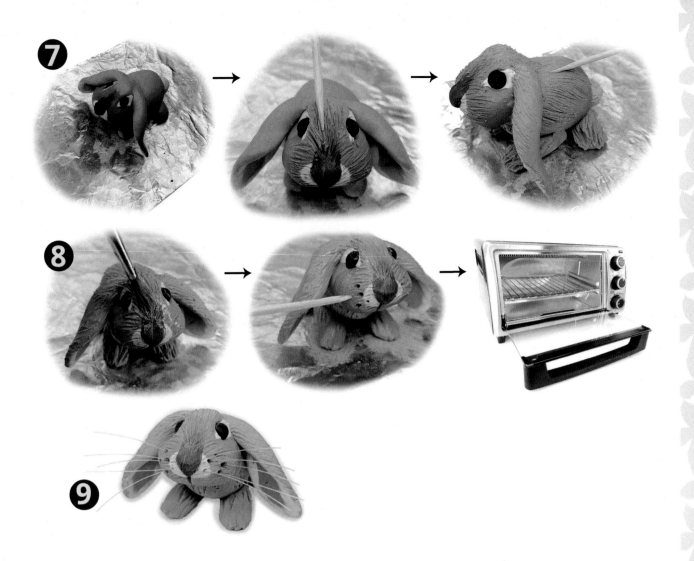

7 Place the sculpture on a foil platform.

Texture the face by lightly scoring straight lines with a toothpick. Continue texturing the legs, body, and tail.

8 Smooth the surface with a brush and small amount of baby oil.

Poke 5 small holes on each cheek with a toothpick to create the whisker pores.

Bake the sculpture at 250°F for 20 minutes. Wait until the sculpture cools off before handling to prevent breakage.

9 Lightly dip the tips of each whisker in clear-gel super glue then place them in the whisker pores.

Giraffe

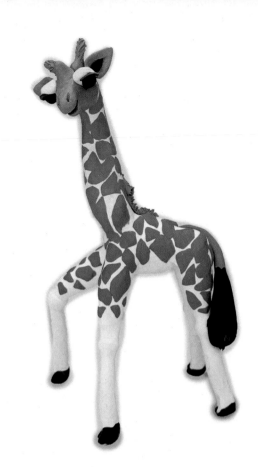

create These forms

You will bake the eyes before adding them to the sculpture. Strictly follow the instructions on the next page.

TOOLS NEEDED:

- Several toothpick pieces and scissors

- Piece of card

- Brush and baby oil

- Rolling pin

- Balls of aluminum foil

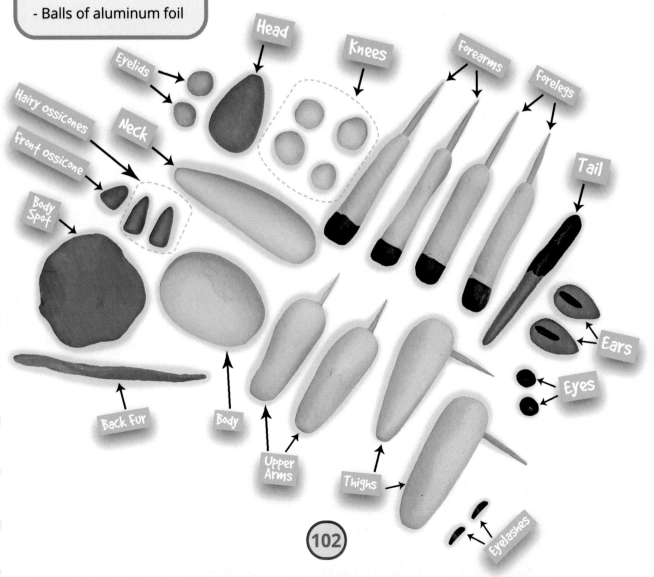

Eyelids

Head

Knees

Forearms

Forelegs

Hairy ossicones

Neck

front ossicone

Tail

Body Spot

Ears

Eyes

Back fur

Body

Upper Arms

Thighs

Eyelashes

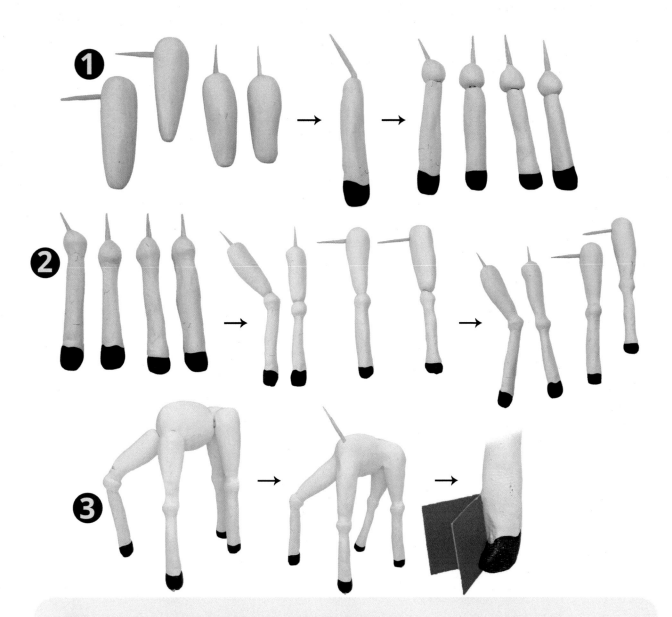

1 Prepare the thighs and upper arms.

Take one forearm then carefully bend the toothpick skewer diagonally. Attach the knees by sliding them onto the skewers of the forearms and forelegs.

2 Blend the connections between the knees and the forearms and forelegs.

Connect one upper arm to the forearm with a bent toothpick. Connect the other upper arms to the other forearms. Blend all the connections.

3 Attach the two formed front legs to the front of the chest area then attach the two formed hind lower legs to the back side of the body. Blend all the connections.

Insert a toothpick diagonally at the top part of the chest.

Create an indentation on each middle foot with a card tent tool to create the hoof.

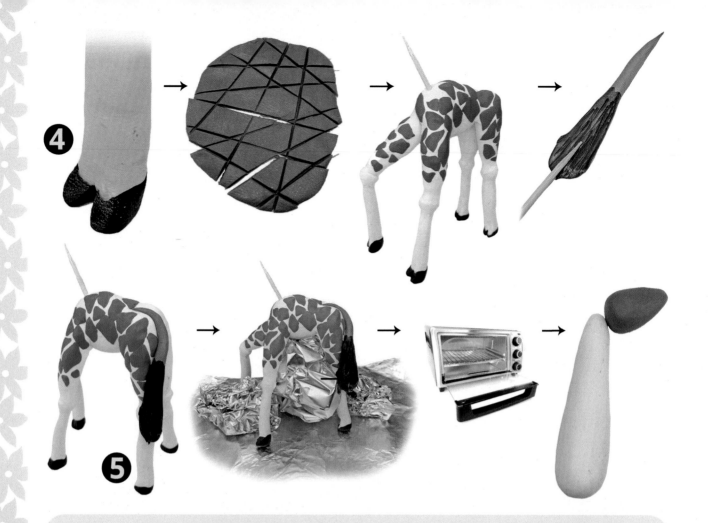

④ Flatten the body spot clay with a rolling pin. Slice the body spot clay with a piece of card in lines to create small geometrical shapes. Individually attach each piece of the body spots on the body. Flatten the body spots by rolling the flat part of a paint brush on the body. **Note: Make sure that the body spots are spaced widely apart. The clay will expand when flattened into place.**

Flatten the black tip of the tail then texture it by scoring with a toothpick.

⑤ Attach the tail at the buttocks area then smear the connection.

Prepare the sculpture on a foil platform. Create balls of aluminum foil and place them underneath the sculpture.

Note: Make sure that the sculpture is very stable standing upright with all the aluminum balls in place.

Bake the sculpture at 250°F for 20 minutes. Wait until the sculpture cools off before handling to prevent breakage.

Attach the head diagonally on the narrow end of the neck.

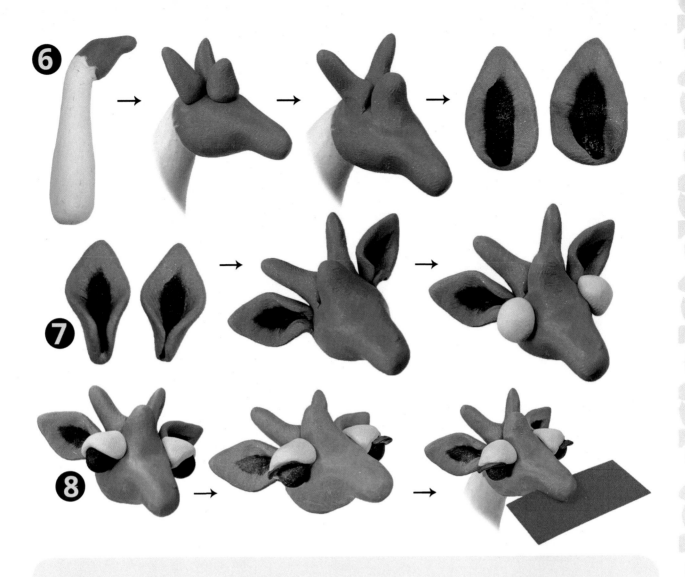

6 Lightly smear the connection between the head and neck.

Form the snout out of the head clay, making the snout slightly thinner. Attach the two hairy ossicones at the top back of the head then add the front ossicone at the front middle of the hairy ossicones. Blend all the connections.

Prepare the ears clay. Lightly smear the edges of the inner part of the ears.

7 Curl the bottom side of each ear inwards. Attach the ears to the sides of the head and point them diagonally upwards. Blend the connections. Add the eyelids right in front of the ears.

8 Add and depress each baked eye right under each eyelid. Attach each eyelash right below each eyelid.

Create the mouth by slicing the snout with a piece of card horizontally.

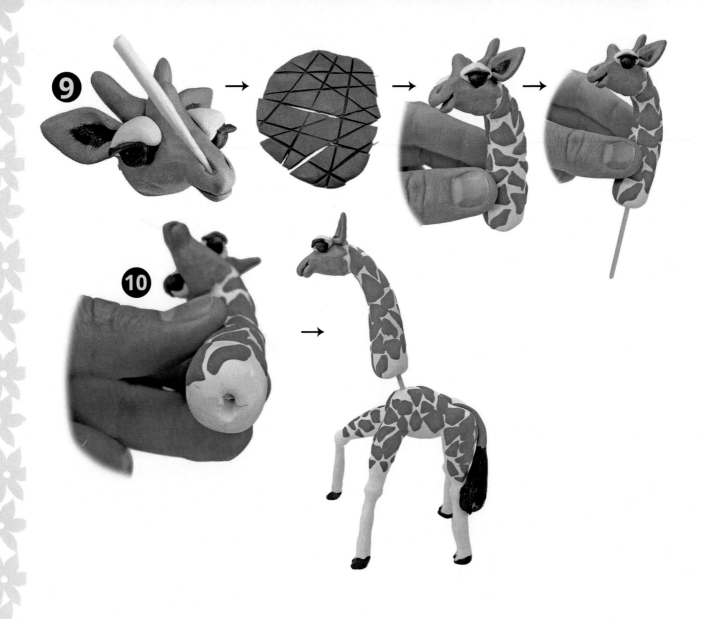

9 Use a toothpick to create two holes for the nostrils.

Repeat the process from step 4 to create more body spots for the neck. Cover the neck with more body spots.

Take a toothpick and poke it through the bottom of the neck to create a skewer for stability.

10 Make sure that the neck toothpick skewer is hidden.

Connect the head and neck formation on the toothpick skewer of the baked body piece.

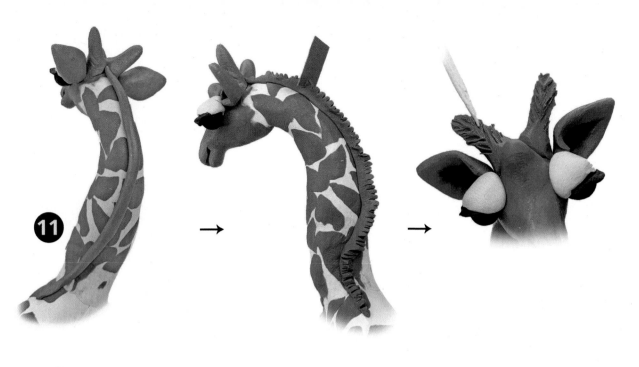

11 Attach the back fur along the back of the neck. Flatten the back fur by pinching it with your fingertips.

Create tightly spaced indentations on the entire back fur by slicing it with a piece of card.

Texture the two hairy ossicones with a toothpick.

12 Prepare the whole sculpture on a foil platform, securing it while standing upright with balls of aluminum foil.

Note: If you need to bake the sculpture in a lying position due to the size of your toaster oven, make sure to prop the head, ears, and any thin parts with small balls of aluminum foil to prevent them from deforming during baking.

Bake the sculpture at 250°F for 20 minutes. Wait until the sculpture cools off before handling to prevent breakage.

Hedgehog

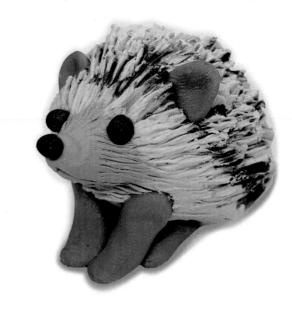

create These forms

You will bake the eyes and ears before adding them to the sculpture. Strictly follow the instructions on the next page.

TOOLS NEEDED:

- Piece of card

- Brush and baby oil

- Toothpicks and scissors

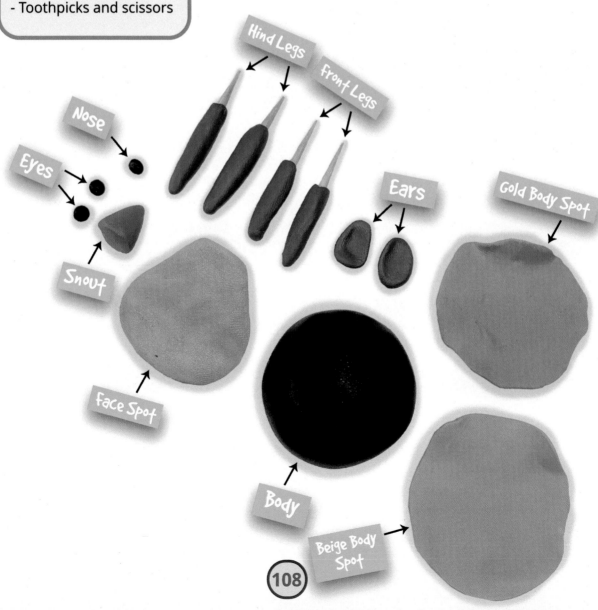

Hind Legs

front Legs

Nose

Eyes

Ears

Gold Body Spot

Snout

Face Spot

Body

Beige Body Spot

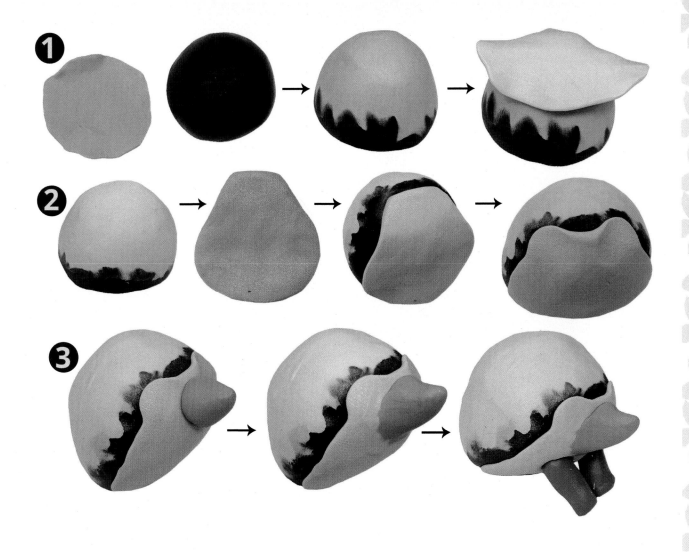

① Place the gold body spot on top of the body then smear all the edges in a downward direction. Add the beige body spot on top of the gold spot.

② Smear the beige body spot down, covering the gold body spot.

Attach the face spot at the bottom of the body. Using your fingertip, press the two top edges of the face spot upwards, keeping the middle section unpressed.

③ Attach the snout to the middle part of the face, just under the unpressed clay, then lightly smear the connection between the snout and the face spot.

Attach the two front legs under the snout at a slight diagonal.

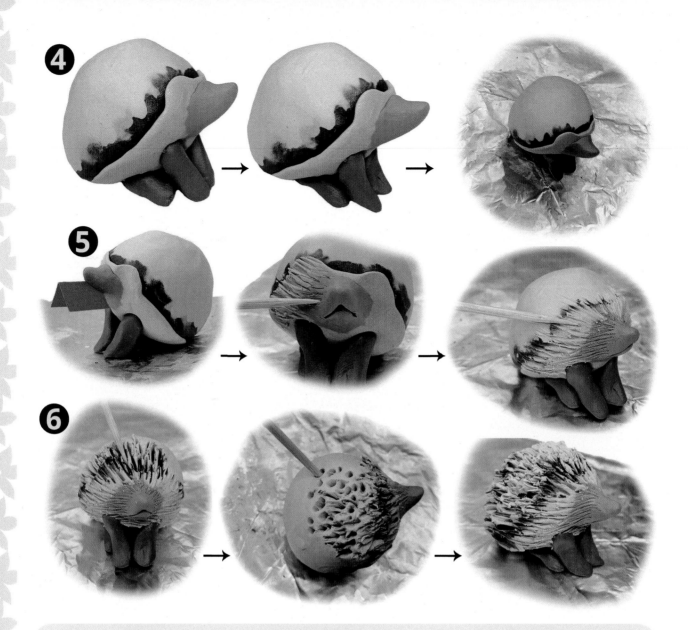

4 Add the two hind legs behind the front legs. Form the tips of the legs pointed.

Place the sculpture on a foil platform.

5 Using a card tent tool with the folded edge at the top, slice the snout to create a mouth.

Texture the sides of the snout with a toothpick by lightly scoring the surface horizontally.

Continue to score the face spot in the same direction.

6 Texture the body towards the back with a toothpick. Deeply score the clay.

Poke holes in the beige body spot scoring outward. This will expose the colors of the gold body spot and the brown body underneath the beige body spot.

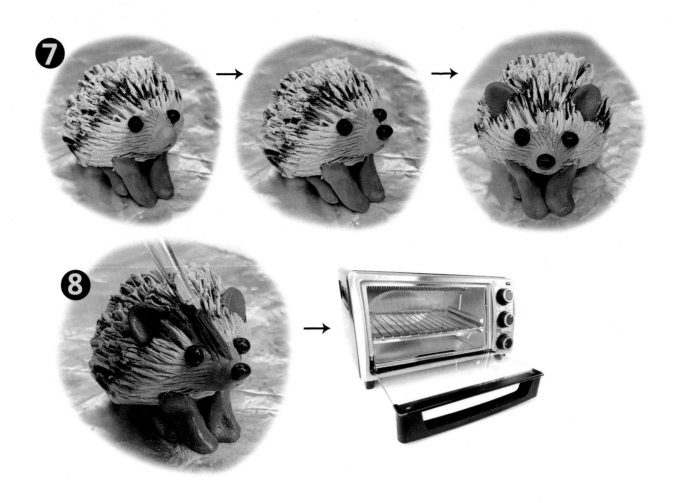

7 Add the baked eyes to the sides of the face.

Add the nose to the end tip of the snout.

Attach the baked ears to the sides of the head.

8 Lightly smooth the surface with a brush and small amount of baby oil, following the directions of the scored lines.

Bake the sculpture at 250°F for 20 minutes. Wait until the sculpture cools off before handling to prevent breakage.

Red fox

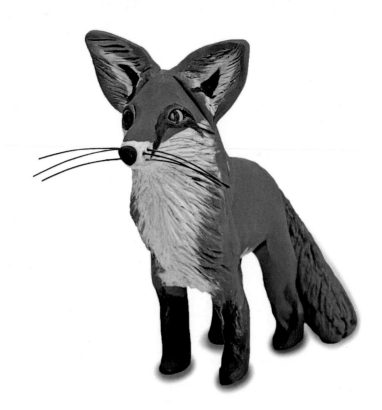

create These forms

You will bake the eyes with irises before adding them to the sculpture. Strictly follow the instructions on the next page.

TOOLS NEEDED:
- Toothpicks and scissors
- Brush and baby oil
- Clear-gel super glue
- Fishing line
- Black permanent marker

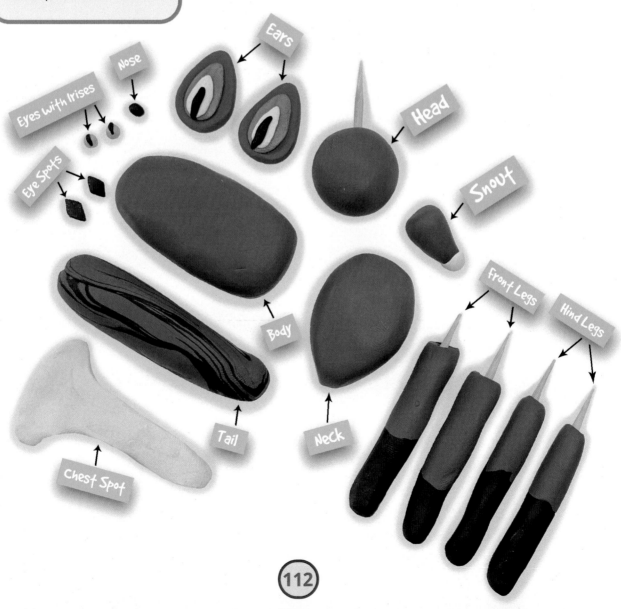

Eyes with Irises

Nose

Ears

Head

Snout

Eye Spots

Body

Neck

Tail

Chest Spot

Front Legs

Hind Legs

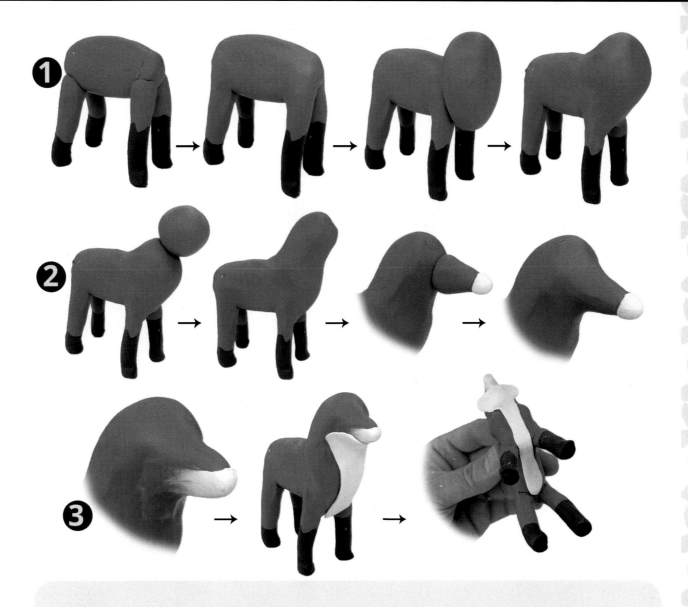

1 Attach the front and hind legs to the body then blend the connections.

Attach the neck to the front of the chest area then blend the connection.

2 Attach the head on top of the neck then fully blend the connection.

Attach the snout to the front of the head then blend the connection only at the base of the snout.

3 Smear the white tip clay only at the lower part of the snout towards the neck.

Add the chest spot to the front of the chest area. Extend the chest spot towards the belly and hind legs.

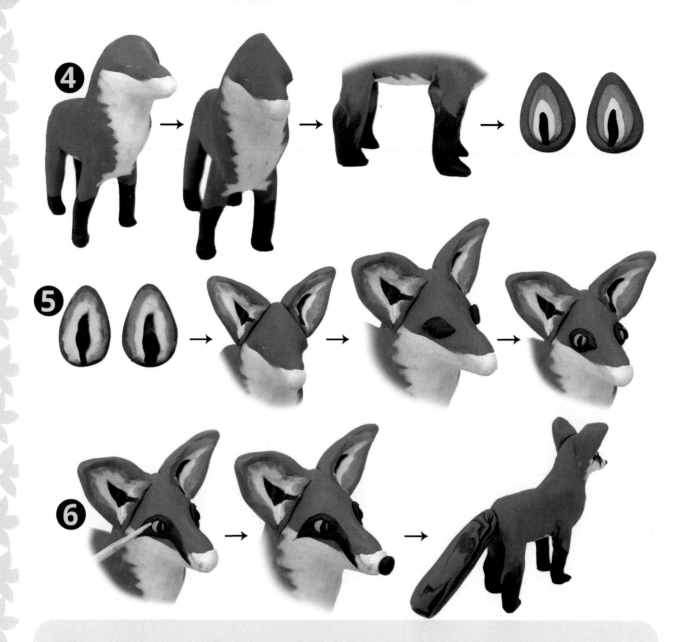

4 Smear all the edges of the chest spot towards the body.

Form the top part of the head into a triangle shape pointed up.

Form all the feet pointed forward. Pinch the clay to create the hock and elbows. Smear the dark clay upwards. Prepare the ears clay.

5 Lightly smear the edges of all the colored layers outward to create a gradient effect.

Attach the ears to the upper sides of the head and form each ear into a triangle shape.

Add the eye spots on the face then add and depress the baked eyes in the middle of each eye spot.

6 Smear the front part of each eye spot down the side of the snout. Use a toothpick to score the back side of the eye spots down towards the cheeks. Add the nose. Attach the tail.

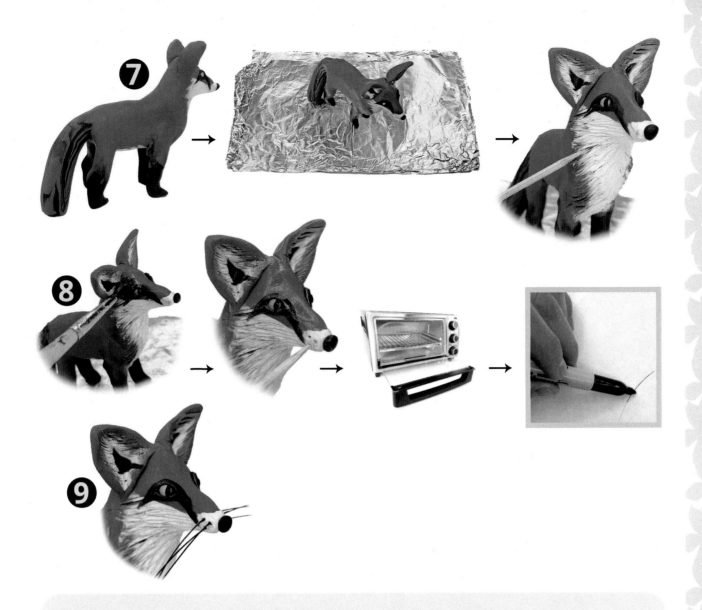

7 Blend the connection between the tail and body.

Place the sculpture on a foil platform.

Texture the white chest spot and the inner parts of the ears with a toothpick by scoring lines.

8 Smooth the surface with a brush and small amount of baby oil.

Poke three holes on each front side of the snout with a toothpick to create the whisker pores.

Bake the sculpture at 250°F for 20 minutes. Wait until the sculpture cools off before handling to prevent breakage.

Paint or color each fishing line whisker with a black permanent marker.

9 Lightly dip the tips of each whisker in clear-gel super glue then place them in the whisker pores.

Pig

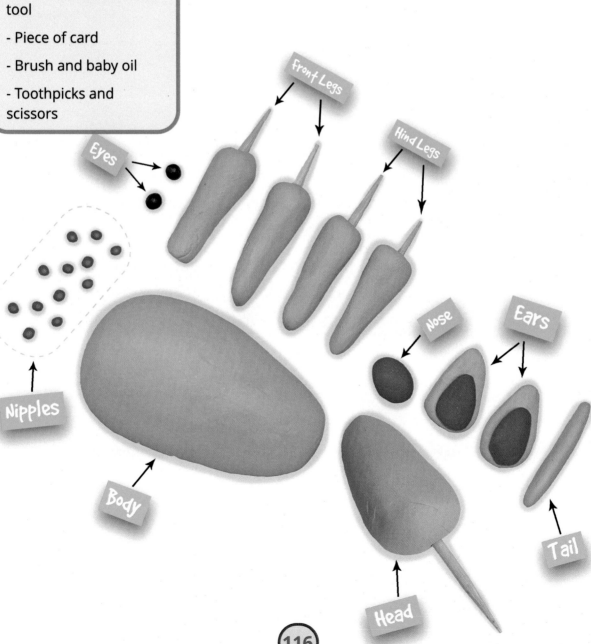

Create These Forms

You will bake the eyes before adding them to the sculpture. Strictly follow the instructions on the next page.

TOOLS NEEDED:

- Small-sized ball stylus tool

- Piece of card

- Brush and baby oil

- Toothpicks and scissors

Front Legs

Hind Legs

Eyes

Nose

Ears

Nipples

Body

Head

Tail

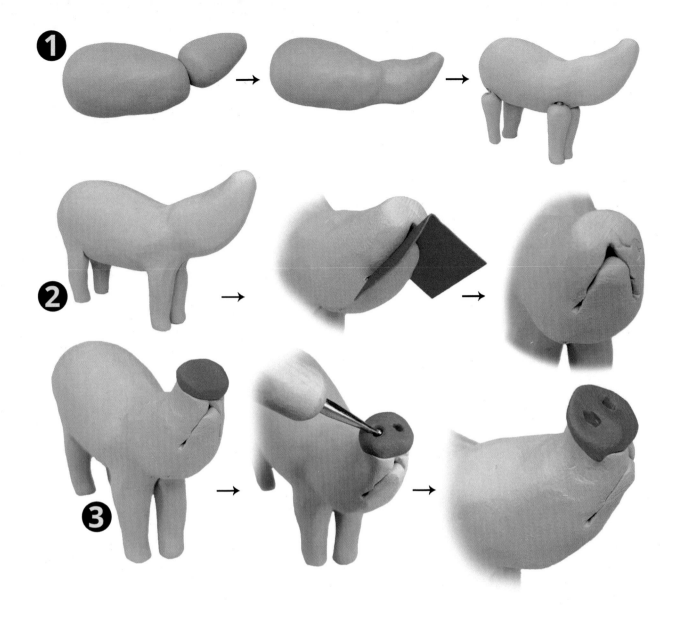

1 Attach the head to the body then blend the connection.

Attach the front and hind legs to the body.

2 Blend the connections between the legs and body, smearing the clay towards the body.

Using a card tent tool with the folded edge pointed upward, slice the front of the head to create a mouth.

3 Place the nose at the front of the snout. Poke two holes in the nose with a small-sized ball stylus tool. Pinch the top tip of the nose and lightly press each nostril with a fingertip to create shallow dips.

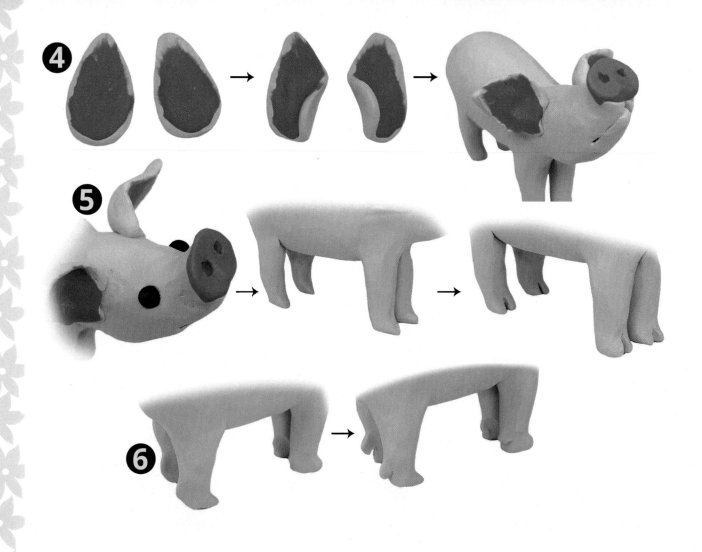

4 Smear the inner edges of the ears but leave some clay unsmeared. Curl the inner bottom part of the ears inward. Attach the ears to the upper sides of the head then blend the connections.

5 Add the baked eyes on each side of the head.

Form the tips of the feet pointed. Slice the middle part of each foot with a card tent tool to create the hoof.

6 Pinch the heel area of each foot then make a small slice with a card tent tool to create the back of the hoof.

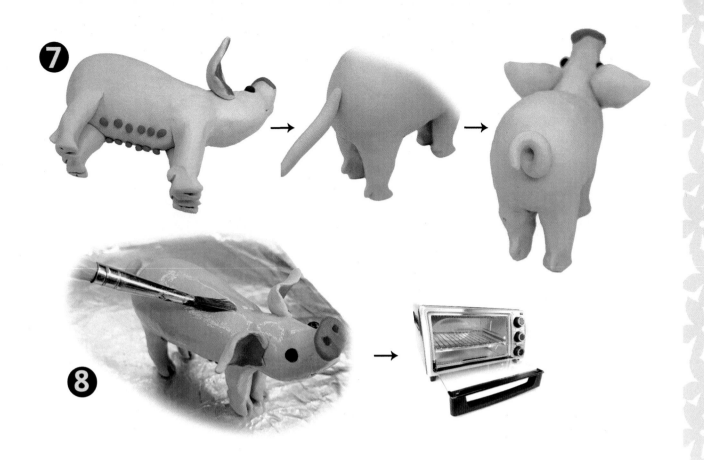

7 Add all twelve nipples on the belly with six on each side in a parallel position.

Attach the tail then blend the connection. Curl the tail.

8 Place the sculpture on a foil platform then smooth the surface with a brush and small amount of baby oil.

Bake the sculpture at 250°F for 20 minutes. Wait until the sculpture cools off before handling to prevent breakage.

African Elephant

Create These Forms

You will bake the eyes, tusks, and nails before adding them to the sculpture. Strictly follow the instructions on the next page.

TOOLS NEEDED:

- Toothpicks and scissors
- Brush and baby oil

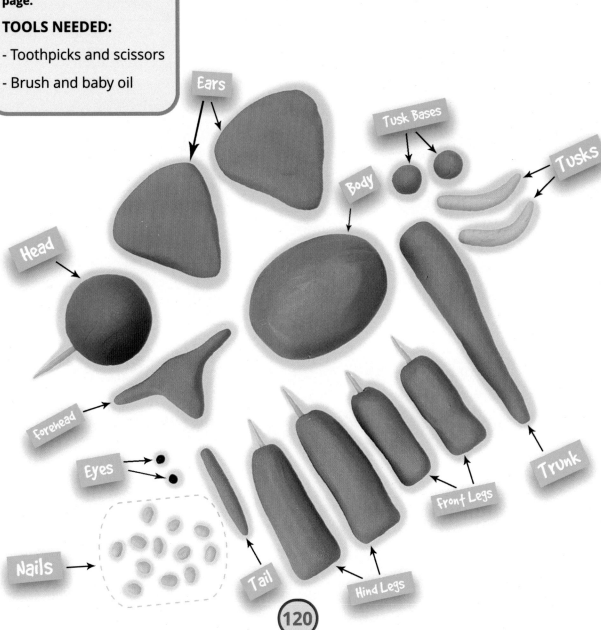

Ears

Tusk Bases

Body

Tusks

Head

Forehead

Eyes

Nails

Tail

Hind Legs

Front Legs

Trunk

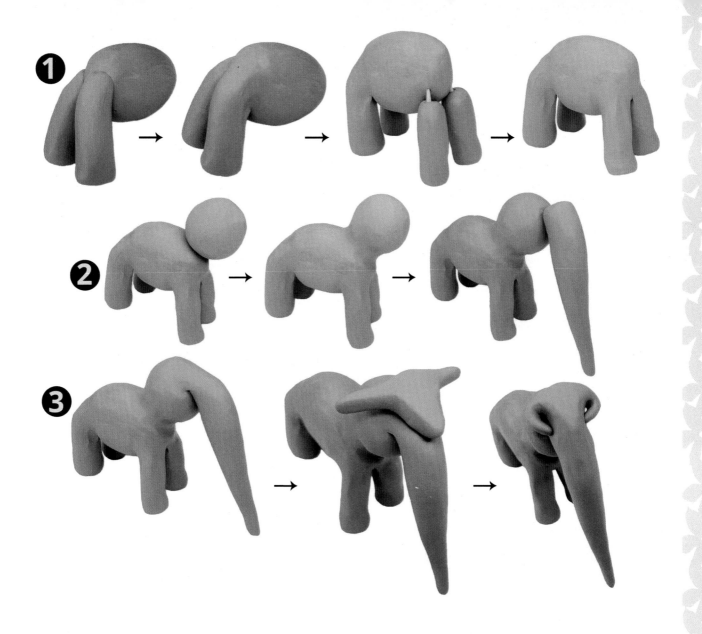

1 Attach the hind legs to the bottom of the body then blend the connections. Attach the front legs to the front of the body then blend the connections.

2 Attach the head to the body then blend the connection by smearing the head towards the body. Attach the trunk to the front of the head.

3 Blend the connection between the trunk and head only at the top of the trunk.

Attach the forehead to the top of the head. Blend the connection at the middle bottom part of the forehead down the nose. Curl both side tips down towards the forehead.

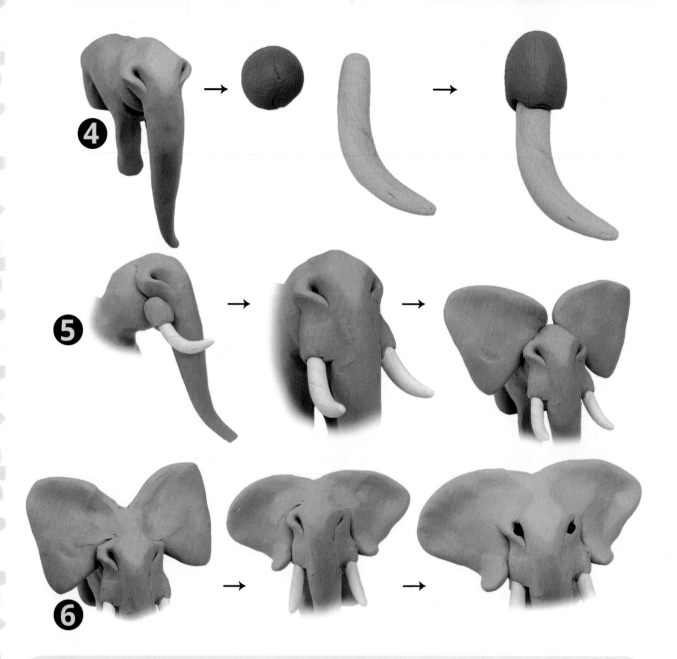

4 Blend the connections of the side tips of the forehead.

Cover the rounded tip of the baked tusk with the unbaked base tusk.

5 Attach the tusk formation to each side of the nose right below the forehead then blend the connections.

Add the ears to upper sides of the head.

6 Blend the corners of the ears at the top of the head together and towards the head. Bend each ear down then make a small curve in the lower tips of the ears.

Place and lightly depress the two baked eyes inside each dip in the forehead.

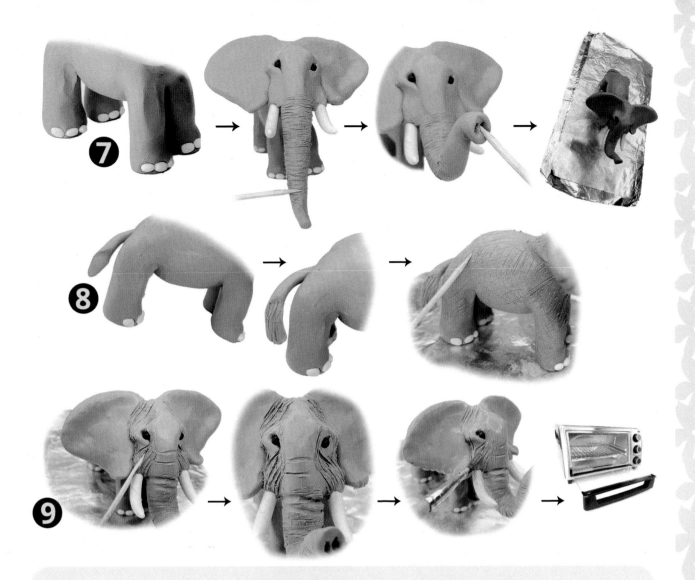

7 Attach three baked nails horizontally on the front side of each foot.

Texture the nose by scoring the surface with a toothpick horizontally. Maneuver the nose to bend upward then poke two holes at the tip of the nose to create the nostrils.

Place the sculpture on a foil platform.

8 Attach the tail, blend the connection between the tail and body, and then pinch the end tip. Score the end tip with vertical lines using a toothpick.

Lightly score the whole body and legs in a cross-hatch pattern.

9 Texture each side of the forehead by scoring lines diagonally. Texture each cheek by scoring lines from the eye corner towards the bases of the tusks diagonally.

Smooth the surface with a brush and small amount of baby oil.

Bake the sculpture at 250°F for 20 minutes. Wait until the sculpture cools off before handling to prevent breakage.

A MESSAGE FROM THE ARTIST

Hello to all who have a copy of *DOGGO BAKE For Beginners! BOOK ONE, DOGGO BAKE For Beginners! BOOK TWO, DOGGO BAKE For Beginners! BOOK THREE, DIY Realistic Dog Sculptures 1 (French Bulldog Edition), KITTY BAKE Polymer Clay,* or any other JFCRN book! We would love to see your creations!

Please use the hashtag #ImadeitJFCRN on social media and tag your sculpture projects so that your work can inspire others.

Thank you so much!

#ImadeitJFCRN

TWO, and BOOK THREE for 60 dog breeds to create, and the KITTY BAKE For Beginners! for 20 cute cat breeds.

Are you ready to create a more realistic sculpture? Try our DIY Realistic Dog Sculptures 1.